$4.30

PHO

D0727676

This book is intended for the beginner with a fairly inexpensive camera as well as for the enthusiast wanting to experiment with more complex equipment or in need of a refresher on fundamental principles. For it is not the camera but the man behind it that counts, and the aim of this book is to show that technical perfection can be easily acquired.

Chapters cover the initial choosing of a camera, explanation of its parts and the different sorts of lenses, flash, films, filters, instruction about exposure, the taking of landscapes, action pictures, night photography, outdoor and indoor work, portraiture; how to develop your own film and prints; and finally how to present your prints and transparency slides in the most attractive way.

TEACH YOURSELF BOOKS

PHOTOGRAPHY

R. H. Mason, M.A., F.I.I.P., Hon. F.R.P.S.

Editor of *Amateur Photographer*
Past President of the Institute of Incorporated Photographers
Past President of the Royal Photographic Society

TEACH YOURSELF BOOKS
Hodder and Stoughton

First printed 1974
Fourth impression 1977
Fifth impression 1978

This volume published in the U.S.A.
by David McKay, Company Inc., 750
Third Avenue, New York NY 10017

ISBN 0 340 19084 1

Printed and bound in Great Britain for
Hodder and Stoughton Paperbacks, a division of Hodder
and Stoughton Ltd, Mill Road, Dunton Green, Sevenoaks,
Kent (Editorial Office: 47 Bedford Square, London WC1 3DP)
by Richard Clay (The Chaucer Press) Ltd, Bungay, Suffolk

Contents

Introduction

'Old myths die hard' and there are two widely held views on photography as a hobby which once had some validity but are not true today. One is that photography is expensive and the other is that it requires a high degree of technical knowledge.

Any hobby must involve some expense, but photography is, or need not be, any more expensive than fishing, stamp collecting, golf, archaeology or any other pursuit. It has a great advantage over many hobbies; you can spend as little as you like, as much as you like or settle for something in between.

It is possible to take good photographs with the cheapest of cameras and a minimum of expenditure on processing. Better cameras will provide more versatility and the ability perhaps to photograph a black cat in a coal cellar, but for most work it is not the camera but the man behind the camera that counts.

What technical knowledge is required? A great mystique has been built up over the last hundred years, encouraged I suspect by photographers themselves, but enormous improvements in apparatus and films have made technical failure almost impossible if reasonable precautions are taken. In fact, technical perfection is easily acquired, and this book aims to put you on the right path painlessly and without a lot of technical jargon.

Photography is unique in that it can be practised indoors and outdoors, summer and winter, day and night. When you are not taking pictures you can be making prints if you have darkroom facilities, and altogether it can provide a most absorbing and satisfying pastime which exercises your imagination and creative ability to the full.

Some people are interested only in using a camera for holiday records or family portraits, but their efforts can be improved by following some of the advice given in this book. Others are

interested in photography as a complement to, or a means of recording, other interests such as natural history, motor sport or geography; they too will be able to improve their results by a basic knowledge of how photography works.

As for the enthusiast, I do not pretend that this book will satisfy all his wants because it starts from the very beginning, but a refresher on fundamental principles is always salutary and I have endeavoured to give some guidance for further study throughout the book.

Many successful professional photographers started as amateurs, and indeed are still amateurs at heart, so this book will be useful as an introduction whether you plan to use your camera just for casual snapshotting or as a tool for serious work in the future.

R.H.M.

1 Choosing a Camera

It may seem like an oversimplification to say that a camera is nothing but a box with a lens at one end and a sensitive surface at the other, together with some means of controlling the latter's exposure to the light passed by the lens. Yet that has always been, and still is, the basis of a camera. In the early days of photography before the 1840s cameras were simple, wooden, light-tight boxes having a lens and a slot or slide to take a sensitised plate. Exposures were made by removing and replacing a cap over the lens, and the camera had to be taken into the darkroom to be unloaded.

In the 1840s slide holders were introduced and other improvements such as bellows or sliding boxes, one inside the other for focusing purposes, made cameras a little easier to use. Primitive shutters to control exposure timing, together with 'stops' consisting of brass strips punched with holes of various sizes to control depth of field, arrived soon after.

Many very fine photographs were taken with these cameras and examples can be found in several museums. Nevertheless, one almost needed the strength of an ox to carry all the equipment to a desired location and, since plates had to be developed and coated on the spot, a portable darkroom was required. One of the most famous pioneers, Roger Fenton, had to convert a horse-drawn baker's van into a darkroom to take to the Crimean War in 1855; so one needed a deep pocket as well!

For sheer quality and artistry it would be hard to beat many of the pictures taken in the first thirty or forty years of photography, which goes to prove that it is the man (or woman!) behind the camera that counts. Modern cameras, even the modestly priced ones, are marvels of sophistication when compared with the early models, but the basic function is still the

same. All the refinements, gadgets, aids and improvements that have been introduced make photography a great deal easier by removing many technical problems, but they do not tell you where to point the camera and how to select the subject.

Some technical knowledge is, of course, essential. Just as a painter must learn how to mix colours so the photographer must learn how to use a camera, and this means that he must also understand how it works. He must select the right camera for the purpose, and this is the first problem facing those who want to take up photography because there are a number of different types from which to choose.

Unfortunately, there is no such thing as a perfect or universal camera because the requirements for different types of photography vary and they could not be incorporated in one camera without making it so big and heavy that it would certainly not be portable. As a result there are many designs and types for special purposes, but we are only concerned here with the types in general use. They are:

Non-reflex
Single-lens-reflex
Twin-lens-reflex

There are a number of subdivisions within these categories, but before going into detail let us look briefly at the function of the various components of a camera, most of which are common to all types.

The lens

First we have the lens whose function is to project an image of the subject onto the film, and on all but the simplest cameras it is necessary to vary the distance between the lens and the film according to the distance of the subject from the camera. This distance has to be increased for near objects and reduced for distant objects. On many old cameras this was done by inserting folding light-tight bellows between the lens panel and the body of the camera. There are still a few models of quite up-to-date

design that use simple bellows. However, most modern cameras, especially of the miniature type, employ some form of lens mount which goes in and out on a helical screw when the mount is rotated.

The iris diaphragm

It is also necessary under certain circumstances to control the amount of light passed by the lens, as we shall see later. In the early days this was done by inserting strips of metal with holes of different sizes pierced in them and these were known as Waterhouse stops. Today nearly all cameras are fitted with an iris diaphragm and this is usually built into the lens mount, sometimes between the component lenses. The diaphragm has a number of very thin metal leaves so arranged that they leave an aperture in the centre that can be varied in size as required—rather like the iris of the human eye.

The shutter

All modern cameras are fitted with a shutter, which controls the *time* that the sensitive film is exposed to the light passed by the lens, as distinct from the *aperture*, which controls the *amount*. There are two basic types of shutter: the 'between-lens' or 'diaphragm' shutter and the 'focal-plane' shutter. The former, as the name implies, is built into the lens mount and is something like a simpler form of iris diaphragm, except that the leaves always remain closed completely when the shutter is not actually in use. On activation they open fully to permit the passage of the light rays.

The focal-plane shutter is basically a curtain of rubberised material with a slit in it that travels from one roller to another just in front of the film itself. In its modern sophisticated form it consists of more than one curtain so that the width of the slit is variable and the speed of travel can also be regulated.

Film transport

Any camera that uses roll film or cassettes must have some means of moving the film into position for the next exposure.

On most modern cameras it takes the form of a lever, which is also coupled to the shutter mechanism in such a way that double exposure is prevented. All shutters require 'tensioning' or 'cocking' to wind up the springs needed to operate the shutter. Winding on the film also cocks the shutter, which cannot be tensioned separately. Very often the same thumb lever also winds on the film number indicator. This is important because films are too sensitive to allow red windows like those that were fitted on the back of old cameras to reveal numbers printed on the film backing paper.

Some of the larger cameras still use the 120 size roll film which is wound from one reel to another and then removed for processing. Most cameras using this film produce either twelve negatives 6 cm × 6 cm or eight negatives 6 cm × 8·2 cm. There is also a size known as 220, which is similar to 120 but provides twenty-four negatives instead of twelve. It only fits cameras especially designed or adapted for it and will not go into all 120 size cameras. Other roll film sizes are now almost obsolete.

A vast number of modern cameras use the 35 mm cassette, and the film is drawn through the camera and then has to be wound back into the cassette before removal. Cassettes usually provide either twenty or thirty-six negatives size 24 mm × 36 mm.

A fairly recent introduction for miniature cameras is the cartridge, which is a light-proof plastic container having a reel at each end and a cut-out aperture in the centre. The camera transport winds the film from one reel to the other and the whole cartridge is then removed for processing. There are two sizes, designated 110 and 126. The former provides twelve negatives 13 mm × 17 mm and the latter twelve negatives 28 mm × 28 mm.

The viewfinder

Although not absolutely essential, it is obviously desirable to have some means of assessing the area of the subject that is being recorded by the camera. A simple wire frame will do this, and on many older cameras a little reflex-finder was a good

enough guide for distant subjects. Today an optical viewfinder is usually built into the camera body. It is reasonably accurate for average subjects and gives a bright picture the right way up, but it is not accurate for close-ups unless some provision is made for tilting it or allowing for parallax error, as we shall see later.

A more accurate method is found in the single-lens-reflex type of camera because this has a ground-glass screen that shows exactly what the lens is covering. On some cameras the screen is the same size as the negative and the image is the right way up but reversed left to right. On others a pentaprism is fitted above the screen so that the image can be viewed from eye level and the right way round.

All these things—lens, diaphragm, shutter, film transport and viewfinder—will be found on every camera, whatever type or price, but other facilities with varying degrees of usefulness are built into many cameras. The most popular are:

Rangefinder focusing
Exposure metering
Flash synchronisation
Automatic or semi-automatic exposure control

They are all to some extent luxuries, but they do make the technical side of photography much easier and facilitate sharp, correctly exposed negatives or transparencies. But let us consider the function of each in turn so that you can decide whether it is essential for your particular requirements.

Rangefinder focusing
All but the simplest cameras have to be focused onto the subject. Focusing is only avoided in the cheapest cameras by using a small lens and limiting the distance at which you can work to nothing less than about 10 feet. (The chapter on lenses explains this more fully.) It is therefore desirable in all but reflex-type cameras to have some means of focusing accurately.

Of course, you can measure the distance from camera to

subject and then set the lens to the corresponding footage (or metres) marked on the rotating mount. But this is not very practical, so many cameras have a built-in rangefinder based on the principle that when an object is seen from two different positions the lines of sight converge. The angle of convergence increases with the nearness of the object and decreases with distance.

Two windows are provided on the camera as far apart as the design will allow and one window is incorporated into the viewer. By rotating the lens mount, which is coupled to a rotating mirror or swinging wedge in the rangefinder, the two images that are seen in the mirror can be made to coincide. The lens is then in focus. It should be mentioned that rangefinders can be bought separately to mount on the camera via the accessory shoe, but they will not be coupled to the lens, so it will be necessary to set the lens manually to the distance figure provided by the rangefinder.

Obviously a rangefinder is not so necessary on a reflex camera that shows the image actually transmitted by the lens because focusing can be performed visually. However, on most miniature cameras the focusing screen is rather small, so a form of rangefinder is provided on the screen. A circle in the centre shows two images or a blurred image which coincide or sharpen when the lens is focused accurately. Unfortunately, these systems, known as the split-image and multiple-prism respectively, are only at their best when the lens is at a large aperture. They are also less efficient with wide-angle and telephoto or long-focus lenses. Nevertheless, they are a help, especially to people with eyesight deficiencies, some of whom find one system easier than the other. It is as well to try both before deciding on a particular make of camera and, other things being equal between two makes, this could be a deciding factor.

Exposure metering
Many of the more expensive cameras have exposure meters built into them and this can be a great convenience. On the

whole they are a reliable guide, but there are subjects of an unusual nature that call for some variation from the indicated figure. These are dealt with in the chapter on exposure, so suffice it to say that it is desirable not to follow a built-in meter blindly but to regard it as a convenient guide rather than an infallible pointer.

On some cameras the meter merely gives an indication of the exposure required and the aperture and/or shutter speeds are set by hand to correspond. On more advanced models a pointer activated by the exposure meter is visible in the viewfinder and one turns the aperture ring or shutter speed dial until another pointer coincides with it, at which point exposure will be correct for an average subject.

On so-called automatic cameras the user merely sets the shutter speed he wants to use and the meter itself opens or closes the aperture to the stop that will give accurate exposure on an average subject. With the introduction of shutters operated electronically instead of by a train of mechanical reaction, it has been possible to make cameras on which the user sets the aperture he desires and the exposure meter adjusts to the shutter speed accordingly. All of the latter are single-lens-reflex cameras and, since they measure the light coming through the lens itself, they are often called TTL (through-the-lens) to distinguish them from other SLR (single-lens-reflex) models.

However, automation has become quite common on ordinary non-reflex miniature cameras as well. They usually have a sensing cell situated on or near the lens mount so that it measures the light direct from the scene instead of from behind the lens. Such cameras are quite reliable if adjustments are made when faced with the unusual circumstances described in Chapter 6 on exposure calculation. It is most desirable when selecting a camera of this type to ensure that it has a manual override to cope with such instances. Provision is made on all cameras with integrated exposure meters to make the necessary adjustments for different film speeds.

While a built-in meter is a convenience, and it certainly makes for quick working, it is by no means essential and has certain drawbacks. If the meter should go wrong it means putting the whole camera out of action while it is being repaired, and there are certain subjects, such as colour work against the light, for which it is a distinct advantage to have a separate meter that can be turned in any direction or taken right up to the subject.

Flash synchronisation

There is hardly a camera made today that does not have provision for firing a flash at the precise moment when the shutter is open. In some of the cheap and popular snapshot cameras a bulb is inserted directly into the camera body and all the necessary batteries or firing mechanisms are built in. This may seem an ideal arrangement but, in fact, it is very bad, for two reasons.

First, nothing looks worse than flash fired from the camera position. It produces ugly, hard shadows, washed-out faces and, very often, nasty reflections from the retinas of the subject's eyes (known as 'red-eye'). Secondly, this type of camera can only use expendable flashbulbs and they preclude the use of an electronic flash, which in the long run is cheaper and more convenient.

That is why all the better cameras are fitted with sockets to take flashguns that have an incorporated mechanism or circuitry for firing the flash. The sockets are connected to the shutter mechanism in such a way that the fractional time delay in opening the shutter or for the bulb to reach the peak of its flash is taken into account and perfect synchronisation is achieved.

On focal-plane shutters it is usually necessary to keep the shutter speed down to 1/60 second or slower to allow for the time the slit in the curtain takes to traverse the negative area. Between-lens shutters can be safely operated at much faster speeds.

The independent 'guns' used for firing flashbulbs and electronic flashguns can both be fired from extension cables plugged into the camera's synchronisation socket. On the rare occasions that it is essential to use them at the camera position, they can be fitted to the accessory shoe found on most models. On some there are built-in contacts which render even the shortest cable unnecessary. These are known as 'hot-shoes'.

Automation

So far camera automation has been confined to exposure setting either by altering the aperture to match a pre-set shutter speed or by adjusting the speed to match a pre-set aperture. Experimental prototypes incorporating automatic focusing have been shown at exhibitions, but they are elaborate and bulky. It will be very many years before they have been perfected and also rendered economically viable, so we have only exposure control to consider when trying to decide on an automatic or non-automatic camera.

The former naturally cost more, so one must consider whether or not the extra convenience is worth it. Most snapshotters and non-enthusiasts would say it is because they find that they only get an exposure failure—once the bug-bear of photography—on the rare occasions that they shoot a non-average subject. On the other hand, professionals and dedicated enthusiasts are inclined to scorn them, just as most motor-racing enthusiasts deplore automatic gearboxes. Very few of the expensive and sophisticated cameras used by professionals and advanced amateurs have automation, but it is not unknown for press photographers to carry one of the compact automatics as a reserve for 'snatch' shots.

So if you plan to remain a snapshotter, buy an automatic camera, but if you are an enthusiast, or likely to become one, spend the money on a more versatile camera like a single-lens-reflex. True, there are a few single-lens-reflex cameras with automation, but these are in the very highest price ranges and one pays dearly for it.

The basic types of camera

Let us now relate the foregoing to the three basic types of camera mentioned at the beginning of this chapter: non-reflex, single-lens-reflex and twin-lens-reflex.

Non-reflex cameras

This category includes any camera that does not show in the viewer the actual image thrown by the lens. It is really our basic box with a lens in the front and a film at the back, but the box has taken on many shapes. There is an enormous range of such cameras, from the Instamatic, successor to the Box Brownie, up to the high-precision Leica.

Most of these are what are known as miniature cameras, i.e. 35 mm or less. There used to be a variety of subminiature models using 16 mm film or smaller and some still exist. There are also a few known as 'half-frame' which use 35 mm cassettes but make negatives half the standard size, thus providing seventy-two shots on a thirty-six exposure roll. However, subminiatures and half-frame sizes are gradually dying out because the advantage of compactness has been largely lost through improvements in the design of the standard models.

The one exception to this is the 110 size, which has facilitated a camera that is truly pocketable and provides a sort of graphic notebook. It is very useful for the holiday snapshotter and as a 'notebook' for the serious photographer but not ideal for serious work, mainly because of its negative size limitation and the impossibility of changing lenses.

This leaves us with the 126 size and the 35 mm size. It is not too broad a generalisation to say that the former is mainly for the snapshotting public and not at all popular with enthusiasts, while 35 mm is popular in both categories.

The advantage of the 126 size is easy loading. The complete cartridge is just dropped into place, while notches on the plastic case adjust the film-speed setting automatically in many cameras made for this size. There is no rewinding to be performed

and the whole cartridge is removed after twelve exposures.

The pundits' dislike of cartridge cameras is based to a large extent on the fact that the precise position of the film is determined by the cartridge itself and they say that plastic can warp. In 35 mm cameras the film is held firmly against the metal aperture by a spring-loaded pressure plate and the film cannot buckle or move. It is only fair to add that the cartridge manufacturers have hotly denied any possibility of their film buckling or leaving the precise film plane, but the fact remains that while there are many popular-priced cameras designed to take cartridges the manufacturers of the top professional and enthusiast cameras have stayed faithful to 35 mm. However, this could be partly due to the fact that a focal-plane shutter cannot be fitted to a cartridge, so the facility for interchangeable lenses is excluded.

There are about thirty models that use 126 cartridges and they vary in price from about £5 to about £30, although there is one well-known make costing over £120. Some are automatic, some have built-in rangefinders for accurate focusing and all are synchronised for flash, although in most cases it is only for flash on the camera.

Non-reflex types which use 35 mm cassettes are on the whole more sophisticated and range in price from about £20 to £450. There are about eighty models on the market. A few have automatic exposure metering and most of these have a manual override. They are all synchronised for flash, using a bulb or electronic flashgun connected by a cable or fired through a hot-shoe on the camera.

There are two principal types of camera in this category: those that have a non-removable lens and those that have a screw or bayonet fitting which enables the user to change very quickly to lenses of other focal lengths, i.e. wide-angle, long-focus, telephoto or zoom. This type is always fitted with a focal-plane shutter, whereas the non-interchangeable type is usually, but not always, fitted with a between-lens shutter. Most of the automatic models are in this category.

Other facilities in this design of camera are rangefinder focusing on the more sophisticated models, delayed-action shutter releases, quick-loading spool devices and film-speed reminders. The basic principle of the camera remains the same and the difference in prices is due mostly to the quality of manufacture, especially of the lens. If a non-reflex camera is your choice it is best to decide first what price you can afford and then compare the specifications of the several models you are bound to find within a few pounds of it. In general, it is better to look for the quality and reputation of the lens in preference to the gadgets or even the looks.

Single-lens-reflex (SLR) cameras

To many enthusiasts this is the most exciting category of cameras. Most of them are designed for 35 mm cassettes, but there are a few larger models made to take 120 roll film.

There are about fifty models in the 35 mm size and prices range from about £30 to £450, with the majority in the £80 to £120 bracket. They all incorporate a hinged mirror which reflects the image up onto a focusing screen. The mirror is automatically raised at the actual moment of exposure, and this is a possible, although minor, criticism of SLR cameras because it means a momentary blackout in the viewfinder and also makes a 'clunk', which could be disturbing to a nature photographer.

On all models a pentaprism is fitted above the screen to provide eye-level viewing and in some this is removable to permit changing the type of focusing screen for special purposes. A number of the more expensive SLRs have a built-in exposure meter, which is coupled to the lens mount in such a way that adjusting the aperture brings a pointer or indicator into coincidence with a datum point or another pointer when exposure is correct. This is usually seen in the viewfinder and in some cases the measurement is based on the average of the light reaching the screen. In others it is 'centre weighted' so that it takes more notice of what is in the centre of the screen than on the outside. This avoids the underexposure that sometimes

occurs when a bright sky or light background influences an outdoor portrait too much.

Since the viewfinder shows the image transmitted by the lens, focusing is simplified, but most SLRs still have a rangefinder of

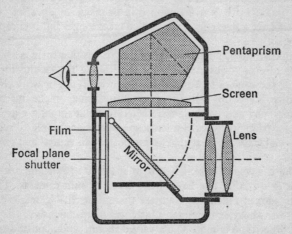

Label: Pentaprism

Label: Screen

Label: Film

Label: Lens

Label: Focal plane shutter

Label: Mirror

Fig. 1 Diagrammatic cross-section of a single-lens-reflex camera showing how the image formed by the lens is reflected by a mirror onto the focusing screen and then at two further angles by a pentaprism. This provides a clear image the right way up. On exposure the mirror rises automatically to permit the film to receive the image, and it also serves to mask the screen, which would otherwise let in light and fog the film.

some sort—split image, split wedge or microprism—as an additional aid. These are very useful for precision work, but many people find that in bright light they can focus quite accurately using the screen alone.

The really big plus of this type of camera is that one can change lenses, and the viewfinder will show the precise image transmitted by each lens. With the non-reflex type that has

provision for interchangeable lenses it is necessary to have some means of altering the viewfinder image to match, and this can become a problem, especially with close-up work, because the lens and finder see slightly different views. There are two main methods of changing lenses. Some cameras have a bayonet ring, which allows a lens to be clipped in or taken out in a second. Others have a screw-in fitting, which takes longer but is cheaper to make.

Another important advantage of the SLR is that there is a vast range of accessories available for the leading makes and these enable the camera to be used for nearly all types of work. For instance, close-up bellows or extension rings make macrophotography and copying easy. Microscope adaptors are available for taking pictures of microscopic specimens, while all sorts of special lenses are available for medical, architectural and press work.

The cameras of the SLR type that take 120 roll film are in some cases rather like larger versions of 35 mm cameras. The advantages of reflex operation are there, but SLR cameras are necessarily heavier and in most instances more expensive.

Another type is more like a very elaborate and sophisticated version of a box camera. Apart from interchangeable lenses, this type also has interchangeable backs which hold the film and enable one to change from black and white to colour or vice versa without going through the whole roll. Although wonderful pieces of machinery, these cameras are large, heavy and very expensive, so they are favoured more by professionals, to whom the film interchangeability is a great asset.

It should be mentioned that 120 roll film, which gives twelve negatives 6 cm × 6 cm, ten negatives 6 cm × 7 cm or eight negatives 6 cm × 8·2 cm, according to the camera, is also obtainable without the paper backing. It is designated 220 size and provides twenty-four exposures 6 cm × 6 cm or twenty-one exposures 6 cm × 7 cm, but it can only be used on cameras especially designed or adapted for it. The interchangeable magazines for SLR cameras all take 120 or 220 film.

Twin-lens-reflex (TLR) cameras

This type of camera is very much like two box cameras fitted one on top of the other. The upper one is like a single-lens-reflex camera with a lens, a 45° mirror and a focusing screen, but it holds no film and the mirror is fixed. The lower half holds the film transport and the taking lens, which has a between-lens shutter. Both lenses are of similar focal length and fixed to a movable front panel so that they can be moved backwards and

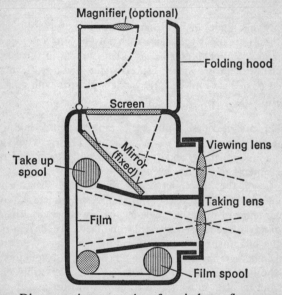

Fig. 2 Diagrammatic cross-section of a twin-lens-reflex camera in which the upper half is used only as a full-size viewer while the lower half takes the picture. The lens moves backwards and forwards for focusing, but only the lower lens has an iris diaphragm and a shutter. Most cameras of this type take 120 or 220 film, giving twelve or twenty-four negatives 6 cm square. Detachable prismatic heads are available for some TLR cameras in place of the folding hood over the screen.

forwards in tandem. Thus the top half is really a full-sized viewer that shows the image the right way up but reversed left to right.

Nearly every TLR available today takes 120 roll film or 120 and 220. The chief disadvantages of these cameras are bulk and weight. Also, it is impossible to judge depth of field or how much of the subject is in focus at a selected aperture because there is no iris diaphragm on the viewing lens. However, some people think that the brilliant viewing image at full aperture outweighs this.

Only one model of TLR camera has interchangeable lenses and these are expensive because each must have its sister viewing lens and a shutter. Nevertheless, TLR cameras in this size are popular with professionals, especially for studio work, but on the score of bulk and cost are far less popular with amateurs than the SLR.

There are, of course, a number of cameras that do not fit any of the categories we have discussed so far. These are individual designs like Polaroid, and stereoscopic, underwater and technical cameras and Kodak instant cameras.

However, the discerning reader will probably have realised by now that the nearest thing to a universal camera, although still far short of it, is the single-lens-reflex camera and its only real disadvantage when compared with others, like the non-reflex and the subminiature, is its bulk and weight. Those who intend to take photography seriously should consider it favourably and buy the best they can in that category. The versatility of the type and the uses to which it can be put will become apparent as you go further into this book.

Further reading about cameras

The Camera You Need, Focal Press.
35 mm Camera, Focal Press.
Camera Movements, Fountain Press.

Detailed test reports on all leading makes can be obtained in reprint form from *Amateur Photographer* magazine.

2 The Lens

The lens is by far the most important component in any camera. The body can be built with the precision of a watch, but if the lens does not form a satisfactory image the rest of it is a waste of money. However, the enormous improvements in lens design and manufacture in the last twenty years have made it possible to take good pictures with the simplest and cheapest, provided that their limitations are understood.

The problem when an image is formed by the light rays passing through glass or any other transparent material shaped in the form of a lens is that various aberrations occur. The picture is distorted in a number of ways and often is not acceptably sharp. Overcoming these faults requires the use of very carefully treated and selected glass, plus very exact moulding or polishing. A tremendous number of mathematical calculations are required to work out the precise curvature for each component. It is reported that a famous lens designer of the 1840s, Joseph Petzval, used a whole company of military engineers to speed the calculations for a new portrait lens. Even so, it used to take anything up to two years to formulate a lens. Today, however, computers have cut it to a matter of hours or even minutes. This has naturally reduced the cost, besides increasing efficiency, and has facilitated the design of an enormous range of lenses for special purposes.

In its simplest form a lens is a circular piece of glass with curved surfaces on both sides or with one side flat and the other side curved. Glass has the property of bending, or refracting, rays of light, and the effect of the surface curvatures is to cause all rays to be refracted at different angles on entering and leaving so that they converge towards each other and meet at a point beyond.

This, of course, applies only to a lens with convex surfaces or with one flat and one convex surface—in other words, a lens that is sectionally thicker in the centre than at the edges. A lens that has concave surfaces, so that it is thicker at the edges than through the middle, causes rays of light to diverge. This means that no image is formed, but divergent lenses are nevertheless sometimes used in a compound lens having a number of components to help correct or counteract aberrations.

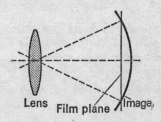

Lens Film plane Image

Fig. 3 The image formed by a single lens is curved in depth, so it is not possible to get the same degree of sharpness all over a flat film plane. If the centre rays are correctly focused, the marginal areas will be out of focus and *vice-versa*.

Nowadays most photographic lenses are made up of a number of different elements in order to overcome the aberrations existing in a single lens. The various elements are often of different shapes and curvatures, and sometimes even vary in the types of glass used.

The principal aberrations that concern us are:

Spherical aberration
Coma
Astigmatism
Curvature of the field
Barrel and pincushion distortion
Chromatic aberration

Spherical aberration

This is the inability of a lens to refract the rays falling on the marginal and central areas to the same point. Thus it is impossible to get a sharp image all over, but improvement can be obtained by 'stopping down', i.e. reducing the aperture of the iris diaphragm so that less of the marginal area is employed. Spherical aberration is present in most single lenses but not to such a degree that it is noticeable in ordinary snapshot-size prints taken with a simple camera working at about f/8 or f/11.

Coma

This is a somewhat similar defect appearing in points away from the axis. The effect is that the image of a circular subject can come out shaped rather like a spinning top. This can also be improved by stopping down. It is usually only noticeable with an extremely contrasty subject like a circular window in an interior shot.

Astigmatism

This is an inability to bring horizontal and vertical lines to focus in the same plane at the top and bottom, or sides, of the field.

Curvature of field

This is seen when rays from the outer edges of the picture do not come to a focus on the same plane as the centre rays. Both astigmatism and curvature are diminished a little by stopping down.

Barrel and pincushion distortion

This arises from a displacement in the position of image points on the outer areas of the field from their true positions so that straight lines near the edges of the picture appear curved. If the lines curve outwards it is called barrel distortion, and if they curve inwards it is called pincushion distortion. This is a common fault in a single lens but is absent or virtually unnoticeable in a corrected lens.

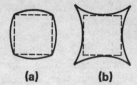

(a) **(b)**

Fig. 4 Common aberrations in simple lenses are barrel distortion (a) and pincushion distortion (b). Straight lines such as the walls of a building that come near the edge of a picture will be curved. It can be improved by stopping down to a small aperture.

Chromatic aberration

This is a fault that results in rays of different colours coming to a focus on different planes. When the camera is correctly focused for one colour, the others are out of focus and colour-fringing results. This was a common fault with old lenses, but most

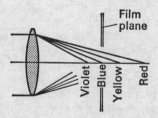

Fig. 5 Some simple lenses suffer from chromatic aberrations that cause light rays of differing colours to come to a focus at different distances from the lens. This produces softness in monochrome and colour fringes in colour work. This exaggerated diagram shows that if the lens is at the correct focus for blue rays the other rays will form circles instead of points on the film.

modern lenses, except for the very cheapest, are virtually free from chromatic aberrations.

It will be obvious from this list of possible aberrations that a single lens is not good enough for photography. Corrections must be made by using more than one lens and by selecting glass with special properties. The more thorough the correction the more complex and expensive the lens will be. Also, the wider the aperture, the more difficult it becomes to make the corrections all over, so this puts the price up as well. To some extent the *focal length* also affects the price—a wide-angle lens often being more expensive than a long-focus or telephoto lens—so let us consider this important characteristic of any lens.

Focal length

The focal length controls the linear size of the images, and it is an expression of the distance between the lens and the film plane when rays from a distant object are in focus. If it is 50 mm the lens will be described as of 50 mm focal length, and this figure will usually be engraved on the lens mount. Strictly speaking, the distance is measured from the rear nodal point of a lens, and in a compound lens this could be inside or outside the lens, but we need not worry about that here, because we are more concerned with understanding focal length than with measuring it.

Most cameras are fitted with a lens, often referred to as a standard lens, which has a focal length approximately equal to the diagonal measurement of the negative. For example, the standard lens on a 35 mm camera is usually about 50 mm (2 in) and on a 6 cm × 6 cm camera it is usually about 80 mm (3¼ in approx.).

Anything substantially less than the standard is called a short focus or wide-angle lens and anything greater is called a long focus lens. Thus an 18 mm, 24 mm, 28 mm or 35 mm lens on a 35 mm camera is short-focus and a 85 mm, 105 mm, 135 mm or

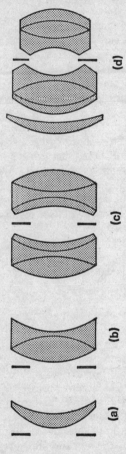

Fig. 6 A simple meniscus lens as shown in section (a) has too many aberrations for satisfactory photography. The achromatic combination (b) is partly corrected and can be used at small apertures. The double anastigmat (c) is almost fully corrected, but its maximum usable aperture (about f/8) is very limiting. The compound lens (d) is a typical ultra-fast lens with excellent correction even at large apertures.

200 mm is long-focus. Likewise, on a 6 cm × 6 cm camera, 55 mm or less is short-focus and 105 mm, 135 mm, 180 mm, 200 mm or 300 mm is called long-focus.

The angle of view of a standard lens focused on infinity is about 55°, and the angle of view for a given size of negative gets progressively greater the shorter the focal length and can be as much as 105°. Conversely, the angle of view gets narrower as the focal length increases, and there is no limit to the focal length that can be used, except for the practical one of sheer size and length.

From this it will be seen that the ability to change lenses on a camera can be very useful. In confined spaces a short-focus lens will permit inclusion of more of the subject than a standard lens, and this is very useful in interiors and crowds. When it is not possible to get close enough to a subject to fill the negative a long-focus lens is invaluable. Sports photography and animal photography in the wild are but two of its many uses.

Telephoto lenses

To get the rays from infinity into sharp focus on the film plane the distance between the nodal point of the lens and the film plane must be equal to the focal length of the lens. On some cameras it is varied for different lenses by means of bellows or some form of extending front, but often it is produced by an extension in the lens mount.

However, with lenses of two or more times the standard focal length, the camera or the lens mount would become extremely unwieldy, so a telephoto lens provides an answer. It is a compound lens in which there is a negative back element of short-focus well separated from a positive front component. This means that the lens-to-film distance can be considerably reduced without affecting the image size. Thus a 300 mm telephoto lens may need only 150 mm between lens and film yet give the same size image as a 300 mm long-focus lens. One pays for this with a slight loss of quality, but not enough to worry about in a good-quality make.

Mirror lens

The mirror lens is another type of compromise that provides a very long focus in a relatively short mount, although it has to be rather large in diameter in order to accommodate concave and convex mirrors. It has a drawback in that it cannot be easily stopped down and it is a lens that is not really convenient for general use.

Fish-eye lens

This is an extremely wide-angle lens that has an angle of view of or near 180°. It produces extreme barrel distortion so that lines near the edge of the field are curved outward and only those through the centre of the subject appear straight. It is useful for astronomy but in other respects is something of a novelty and not suitable for general use.

Zoom lens

This is a lens of variable focal length. There are several groups of elements that can be moved by rotating the lens mount and this alters the size of the image without affecting the focus. The range of focal lengths for a 35 mm camera zoom lens is usually not more than about 100 mm, i.e. 75 mm to 175 mm or 100 mm to 200 mm, and there is inevitably a loss of quality and sharpness, especially at the larger apertures. If this can be overcome and the range widened, a zoom lens may in time save the inconvenience of carrying a number of lenses of different focal lengths, but at present it is still a rich man's toy except for cine work, where the small size makes it practicable.

The iris diaphragm

The iris diaphragm, which is usually fitted between the components of a lens, provides a continuously adjustable aperture that is approximately circular. In order to facilitate exposure calculation a specific range of sizes of aperture are marked on the adjusting ring.

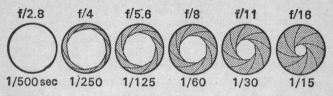

Fig. 7 The iris diaphragm built into the lens mount can be opened and closed like the iris of the human eye. Specific 'stops' are arranged at intervals so that each passes half as much light as the larger one preceding it. Shutter speeds are arranged in a progression, which also halves the exposure for each higher speed. Thus any of the combinations of speed and aperture shown in the diagram give the same effective exposure.

These are given as f numbers and they are the result of dividing the focal length of the lens by the diameter of the aperture. For example, an aperture of 10 mm diameter on a 50 mm lens would be f/5. However, a series has been standardised that runs as follows: f/1·4, f/2, f/2·8, f/4, f/5·6, f/8, f/11, f/16, f/22, and each one of these passes exactly half the amount of light of the previous one. The larger the number, the smaller the aperture, and each higher number will require double the exposure of the previous one.

Depth of field

At one time the use of small apertures, or stops as they are often called, provided a means of reducing lens aberrations. With modern lenses this is hardly necessary since the definition is generally acceptable at any aperture, although there is often a stop at which optimum performance is obtained—usually about f/5·6 or f/8 on a 50 mm lens. However, the iris diaphragm has a very much more important function in giving control over depth of field.

When a camera is focused on a plane at a specific distance there will be planes in front and behind that are acceptably

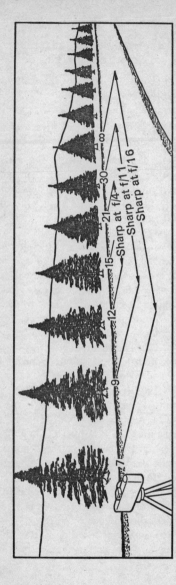

Fig. 8 The distance on which a lens is focused and the aperture in use together control the depth of field within which all objects are reasonably sharp. Here the lens is focused on 15 ft and the figures show the depth of field at three different apertures. Note that there is a greater depth beyond the focused point than in front of it.

sharp, and the distance between the nearest and furthest acceptably sharp planes is called the depth of field. This varies with:

The focal length of the lens.

The distance on which the lens is focused.

The acceptable degree of sharpness expressed as a 'circle of confusion'.

The aperture in use.

The longer the focal length of the lens in use, the smaller the depth of field when the other three factors are unchanged.

When a lens is focused on a near object the depth of field, other things being equal, will be less than when it is focused on a distant object: the variation between, say, a portrait and an object 100 feet away can be considerable.

The acceptable degree of sharpness is a variable factor, but a measurement for a 'circle of confusion' enables it to be expressed in figures and to provide a basis for comparison. It will be seen from Fig. 9 that when rays from a distant object come to a point on the film plane that object is sharp, while rays from objects nearer and further away will form circles instead of points. The largest circle that is permissible will govern the distances between which the depth of field is measured.

It is generally accepted that a circle of confusion of f/1000 (i.e. the focal length of the lens divided by 1000) is a reasonable norm, and many tables giving depth of field for different lenses at different apertures and different distances are based on it. Expressing a circle of confusion as a fraction of the focal length takes care of the fact that miniature negatives made with lenses of 50 mm or less focal length are usually enlarged much more than larger negatives made with longer focal-length lenses. It does not, however, take into account the fact that a miniature negative made with a telephoto lens will probably be enlarged just as much as one made with a standard lens, so theoretically a higher degree of sharpness should be allowed for.

The distance between the planes on either side of the film plane where the permitted circle of confusion occurs is known

as the 'depth of focus'. This term is often wrongly applied to the depth of field.

Variation of the aperture gives a lot of control over depth of field. For any given distance the smaller the aperture, the greater the depth of field. Thus when it is required to throw a back-

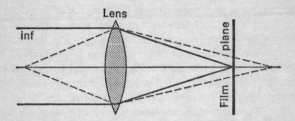

Fig. 9 Rays of light from a far distant point are nearly parallel when they enter the lens, but refraction causes them to come to a point on the film plane when the lens is correctly focused. Rays from a nearer point come to a focus behind the film, so objects at that distance appear out of focus. Conversely, if the distance between lens and film plane is increased so that the nearer objects are in focus, then those at a greater distance will appear out of focus. The circle on the film plane formed by the out-of-focus rays is known as the circle of confusion.

ground out of focus a wide aperture is employed and when it is desired to cover a great depth, as in most landscape work, a small aperture is used.

Minimal depth of field is obtained by using a long focus or a telephoto lens at full aperture on a close-up subject and maximum depth is obtained by using a short-focus lens at the smallest aperture on a distant subject. Between these extremes an infinite range of effects can be obtained and this is a useful factor in the artistic aspect of photography, as will be seen later.

It is wise to remember that for a given size of image and a given aperture all lenses show the same depth of field. However, to obtain images of the same size with lenses of different focal

lengths the distances between camera and subject will vary. This has a bearing on perspective, which is fundamentally the relation in size between objects on different planes. Thus an object close to the camera will look larger in relation to a more distant object than if the camera were taken further away and a longer focus lens used to keep the main object the same size.

Perspective is purely a matter of distance, not of focal length. If an object is photographed at, say, 30 feet on two cameras, one fitted with a 50 mm lens and the other with a 135 mm lens, it will appear much larger on the 135 mm negative than on the 50 mm, but the relative sizes of the object and everything else in the picture will remain the same. In other words, both negatives could be enlarged to give identical prints.

There are many subjects where perspective must be taken into account. If we get very close to the subject in a head-and-shoulder portrait, the nose will appear much too large in relation to the ears. With a standard lens there would be a temptation to get too close in order to fill the negative, and with a wide-angle lens it would be necessary to get so close as to produce a caricature. Therefore a longer focus lens is essential in order to get far enough away to produce proportions that look natural. On the other hand, if we select a very long focus, say a 300 mm on a 35 mm camera, the ears will look too large in relation to the nose. For most portraiture a 105 mm or 135 mm focal length on a 35 mm camera gives the more natural effect.

When photographing distant scenes a very long-focus lens will appear to 'bunch-up' the planes and thus reduce the illusion of depth. This effect is frequently seen on television, where a cricket pitch is apparently reduced to a few feet in length. This is not so much because a long-focus lens is used as because the camera is so far away and the long-focus lens has been used to fill the picture with a small part of the scene.

It is useful to remember that the greater illusion of depth, other things being equal, is obtained when the camera is close to the foreground objects and a lesser impression of depth when the camera is a long way away. This, and the necessity or other-

wise of filling the negative with the subject, will help you to decide what focal length of lens to employ.

Lens coating

When light strikes a glass surface a small amount is reflected back instead of passing through. In the case of a compound lens with a number of surfaces, the loss can be very considerable and internal reflections can also create a degree of fog, which has the effect of reducing contrast.

These problems can be reduced by coating the lens surfaces with an extremely thin and transparent film, usually magnesium fluoride. This is sometimes referred to as 'blooming'. Nearly all quality lenses are coated on some or all surfaces and although it gives the lens a coloured appearance, usually amber, it does not materially affect the colour transmission.

Degradation of the image by internal reflection can also be caused by allowing rays of light from outside the picture area to fall on the lens, whether it is coated or not. Such rays can cause ghost images even though they do not strike the film surface directly. This is a real danger when taking photographs 'against the light' or at an angle to the sun or other bright light source. The remedy is to use a lens hood that is long enough to shield the lens surface from such rays but not long enough to obtrude into the picture. Its use is especially desirable with modern wide-aperture lenses that have a large glass surface which is rarely very deeply recessed into the mount.

Lens converters

These are attachments that can be fitted in front or behind a lens in order to increase or decrease the focal length. When fitted behind the lens they are used to increase the focal length and are usually designated $\times 2$ or $\times 3$. Thus a 50 mm lens with a $\times 2$ converter will have an effective focal length of 100 mm. Those designed for decreasing the effective focal length are always fitted to the front of the lens.

Converters are compact and much cheaper than buying a separate long-focus or wide-angle lens, but there is inevitably some loss of quality in definition. They also decrease the effective aperture of the lens and this complicates exposure calculation. Converters for increasing the focal length are sometimes called tele-extenders.

Lens resolution

To any photographer the sharpness of the image produced by a lens is by far its most important factor. Sharpness, however, is not necessarily measured in the number of lines per millimetre that can be seen in a negative made from a test chart. Indeed, most lenses, even the cheapest, can resolve more lines than the average film emulsion.

Lines on a test chart are usually black on white, thus providing maximum contrast, whereas most photographic subjects are of considerably lower contrast. Often a photograph of a contrasty subject taken with a poor-quality lens will look sharper than a low-contrast subject taken with a good-quality lens. Also, a negative developed in an 'acutance' developer, which produces sharp contours giving a quick transition from one tone to another, will often appear much sharper to the eye.

Nearly all medium-price lenses of modern construction are adequate for normal purposes and comparatively free from aberrations, but if very big enlargements or sparkling exhibition prints are the ultimate aim it is wiser to buy the best.

Further reading about lenses

Optics, Arthur Cox, Focal Press.
The Photographic Lens, H. M. Brandt, Focal Press.
Lens Guide, Leonard Gaunt, Focal Press.

3 Choosing a Flashgun

Not so long ago a chapter on flash would have been at the end of a book on photography, but today it has become an almost indispensable aid that widens the scope of the camera and makes photography possible in any condition. Nearly all professional studios employ flash instead of the tungsten spotlights and floods that cluttered up the set and 'cooked' the sitter only a decade ago. You will rarely see a press photographer without flash, even in bright sunlight, and improvements in design and cost have made it available to every amateur.

There are two basic types of flash: bulbs and electronic flash. Flashbulbs are expendable—they can only be fired once and then have to be thrown away. Electronic flashguns will fire repeatedly until the tube wears out and this may mean as many as 10 000 or more flashes.

Flashbulbs

It was the introduction of foil-filled flashbulbs in 1934 that made camera synchronisation possible and today there is hardly a camera that does not have built-in provision for firing the flash during the fraction of a second that the shutter is open. The original flashbulbs were as big as electric light bulbs and not always reliable; sometimes they failed to fire and sometimes they exploded.

Continuous improvement has brought the size down to little more than a peanut and the modern bulb is both safe and reliable. In its latest form, known as a flashcube, there are four bulbs in a transparent container and each has its own tiny reflector. A variation of this, called a Magicube, does not even require an electric current to fire it.

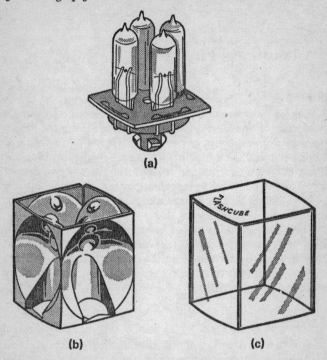

(a)

(b) **(c)**

Fig. 10 An exploded diagram of a flashcube showing the four
tiny blue flashbulbs. The four reflectors above slip down over them
so that each bulb has its own aluminised reflector. The transparent
styrene sleeve which fits over the whole is only $1\frac{1}{8}$ in \times $1\frac{1}{8}$ in \times $1\frac{1}{8}$ in.
The Magicube is similar but has a mechanical instead of electric
means of firing and can only be used on specially fitted cameras.

All bulbs except the Magicube are fired by a current which is
passed through them when the shutter is operated. In order to
make sure of an adequate power supply a battery capacitor
circuit is employed in most flashguns. The capacitor is charged
by the battery through a resistor and when contact is made the

energy is discharged direct from the capacitor instead of the battery, so a consistent 'punch' is obtained even when the battery is running down and is too weak to fire a bulb direct.

Simple 'snapshot' cameras have the capacitor built into the body, together with accommodation for a miniature battery. This means that the flash has to be used on the camera. We shall see later that this is very restrictive and useless for serious photography. Magicubes can only be used on cameras specially made for them because the firing is achieved by mechanical means. No battery is required since a trigger actuates the firing paste by friction. This means that Magicubes suffer the same 'on-camera' disadvantage as flashcubes. Nevertheless, both are an improvement on single bulbs because four flashes can be fired in fairly quick succession and they are cooler to handle after firing. Uncoated flashbulbs give a light that is too warm for daylight-type colour film, but nearly all bulbs are now coated blue in order to overcome this.

For serious work the battery and capacitor circuit are contained in a separate flashgun unit that is connected by cable to the synchronising socket. Some are also fitted with a 'hot-shoe', which establishes a direct connection when the camera accessory shoe has built-in contacts. Flashgun units, which need not be more than about 2 in × 2 in × 1 in and only an ounce or two in weight, can be deployed at any distance from the camera with the aid of an extension cable. They are made to take ordinary capless flashbulbs or flashcubes and, in the case of the former, incorporate a reflector, sometimes of the folding fan variety.

The big disadvantage of flashbulbs is their expense. They can only be used once and the cheapest is about 5p. Allowing for the number of pictures one might have to take to get the right pose or expression, this makes portraiture an expensive pastime, so flashbulbs are losing popularity except with those who indulge in only a few sessions per year.

Electronic flashguns

Electronic flash offers a number of advantages over flashbulbs. The flash is produced by passing an electrical charge from a large capacitor or conductor through a gaseous discharge tube of glass or quartz. The capacitor can be charged from a dry battery, an accumulator or from the mains in conjunction with a rectifier, and some makes have facilities for all three methods.

The flash has a very short duration—about 1/600 second or less. This will 'arrest' most moving subjects and it has approximately the quality of daylight, so it can be used with daylight-type colour film. In the early days electronic guns were very heavy and bulky affairs, usually with the power pack separated from the case containing the tube and the reflector, but today

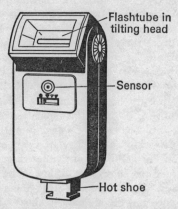

Flashtube in tilting head

Sensor

Hot shoe

Fig. 11 Electronic flashguns come in all shapes, sizes and prices. This is a popular type and it is possible to tilt it for bounce flash. No lead is necessary when the camera has 'hot-shoe' contacts. Many models like this can fire about fifty to eighty shots before the built-in NCd battery needs recharging. Some can also be connected directly to the mains. Many recent models have automatic exposure control by means of a built-in sensor, which quenches the flash when sufficient illumination has been given.

there are many guns that are only fractionally larger than a cigarette packet and less than 8 oz in weight. True, there are professionals who still prefer the separate pack because of its extra power and the fact that it will give more flashes per charge —in some cases as many as 400. However, the smaller single units provide adequate power for most amateur purposes and give 60 to 80 flashes for each battery charge. They are not quite so powerful as the small flashbulbs, but there is not sufficien difference to take into account when weighing the pros and cons of bulbs versus electric.

There are a number of flashguns available even in the smaller sizes, which have a built-in sensor that measures the light reflected from the foreground subject and when exposure has been sufficient the tube is quenched. All this takes place in a tiny fraction of a second and it saves calculating the exposure from the guide number described in Chapter 6. It also saves measuring the distance. On the average subject it works very well, but there are exceptions, so the guns are fitted with a switch that cuts out the sensor and allows exposure to be made with a full discharge in the ordinary way.

The disadvantage of these units when the sensor is built into the gun is that they can only be conveniently used on or near the camera, although there are a few models in the higher price class that have the sensor at the end of a cable. It can thus be placed on the camera while the flash is deployed at an angle to the subject. This also facilitates automatic exposures for bounced flash—something that is impossible with the simpler model. Some of them also have a circuitry that cuts off the flash instead of quenching it. This means that no current is wasted and more flashes per charge are obtainable.

Nearly all electronic flashguns have an angle of coverage of about 60° to 70°, which approximates to that of a standard lens. The flash has a characteristic softness, due to the use of facetted built-in reflectors or matt plastic windows over the tubes, and the pictures taken with it are generally less hard than those taken with flashbulbs.

Many of the small amateur guns use two or four penlight batteries which will give up to forty or fifty flashes. These have the advantage of convenience, and if they run down during a shooting session they can be replaced immediately. Others are fitted with a nickel–cadmium (NCd) dry battery that can be recharged from the mains. These give sixty or more flashes on a charge, but recharging may take anything up to twenty-four hours. However, in the long run, there is a saving in cost because the battery does not have to be replaced. Some of the bigger guns with separate power packs use wet accumulators, which are cheaper but heavier. Electronic flashguns with nickel–cadmium or wet batteries can also be fired by direct connection to the mains via the charging cord and plug supplied. This is a convenience at home if the battery runs out during a session.

The number of flashes obtained will obviously depend on the way the gun is used. If it is left switched on between shots current will be wasted, except in the case of large guns fitted with an automatic cut-out in the circuit.

When contemplating the purchase of a gun its use should be carefully considered. If the intention is to use it mainly for formal indoor portraiture, there is no real necessity for an automatic model and, since weight is not so important, a powerful model, possibly with separate power pack, would be an advantage. On the other hand, candid work at parties, indoor sports or theatricals calls for an easily portable model, and an automatic unit would assist quick working and in getting shots that might otherwise be missed while calculating exposure.

Flash can be useful out of doors, as we shall see later in this book, but power is not so important, so the miniature lightweight models are the obvious choice. Automatic exposure control is useless for synchro-sunlight (fill-in flash outdoors).

The strength of the light given by an electronic flashgun is sometimes expressed in *joules* or watt–seconds. This is not very reliable as a measurement of effectiveness because the watt–second figure is merely a mathematical calculation based on the

storage capability of the capacitor and the voltage applied to it.

It has therefore become customary to quote a *guide number*, usually based on film of 50 ASA speed (see Chapter 4). The quoted guide number divided by the distance of the subject from the camera gives the aperture to use. For example, if the guide number quoted for the gun is 110 with 50 ASA film and the subject is 10 feet away, the aperture to use is f/11. The guide number takes into account the tube construction, reflector efficiency and any other factor peculiar to the gun. It is thus a reliable way of comparing one gun's power against another's. Most flashguns are fitted with a little rotating scale that gives the guide number for different speeds of films and indicates the aperture to use at different distances. The guide number system is also used for flashbulbs and an exposure table is usually printed on the packet.

Slave guns

A useful accessory in flashwork is known as a slave unit or slave gun. When it is desired to use more than one flashgun in synchronisation, a slave unit will obviate the necessity for cables or connections.

It is attached to and connected with one of the flashguns. Firing the other gun, which is connected directly to the camera synchronising socket, causes the slave unit to trigger the gun to which it is itself connected. This is done by means of a photocell or phototransistor which, through an amplifier, closes the contacts of a magnetic relay.

It is powered by a small dry battery and modern units are smaller than a cigarette packet. Often the slave unit is used in conjunction with a main light well away from the camera, while a second flashgun, used for filling in the shadows, is fitted on or near the camera. This is sufficient for firing the main light via the slave unit at any distance up to 20 feet or more. Any number of flashguns can be fired in this way so long as each has a slave

unit, and there will be no wires or cables to trip over. Slave units can, of course, be used with either bulbs or electronic guns. Continuous light, however bright, will not affect them.

Synchronisation

On a static subject when the light level is very low it is possible to open the shutter on 'Bulb' or 'Time', fire the flash and then close the shutter. It is obvious that this cannot be done in bright light, especially with moving subjects, otherwise double images will result and so camera designers have built in a means of firing the flash at exactly the right moment. However, there is a difference in the characteristics of bulb and electronic guns that has to be taken into account. A bulb does not reach its peak until about 20 milliseconds after contact is made, but electronic flash reaches its peak almost instantaneously.

On a between-lens shutter the blades take from 2 to 3 seconds to open fully, so the contact for firing a flashbulb must be made 17 to 18 milliseconds before the shutter starts to open. To achieve this a delay mechanism is built into the shutter, and it is usually operated when the flashgun is connected to a socket marked 'M'. For electronic flash the gun must be connected to the socket marked 'X'. At this setting the flash contacts close in about 2 milliseconds, i.e. when the shutter blades are fully open. It is also possible to use the smaller-type flashbulbs on the 'X' setting at the slower speeds—up to 1/60 second. Electronic flash can be used at all speeds on 'X'.

Synchronisation with focal-plane shutters is not so easy because of the time taken by the slit to uncover the film area. A special type of flashbulb, designated 'FP', is made for the purpose and this can be used on cameras that close the contacts before the first blind begins to move. This bulb has a peak duration that is longer than the shutter travel time on most cameras and it is used via the socket marked 'F' or 'FP'.

Unfortunately, the peak duration of electronic flash is far shorter than the travel time of a focal-plane shutter, so it can

only be used at the slower speeds when the film is fully un-covered. This varies with different makes of camera but is usually about 1/50 or 1/60 second. Anything faster will cause only part of the negative to be exposed.

It will be seen from this that the between-lens shutter has a big advantage over focal plane when it is necessary to use flash in bright light conditions on fast-moving subjects. In a boxing arena, for example, an exposure of 1/60 second might well record a secondary image by the available light as well as the main image illuminated by the flash. This also applies when using flash for fill-in work in bright sunlight. The subject may demand an exposure of 1/250 second or less, but with a focal-plane shutter it would be impossible to synchronise electronic flash. This could, however, be overcome by purchasing a second gun to take an FP bulb. The guns are not expensive but the bulbs cost a little more than the normal ones.

Further reading about flash

Electronic Flash Guide, Leonard Gaunt, Focal Press.
Successful Flash Photography, L. A. Mannheim, Focal Press.
The Focal Guide to Flash, Gunter Spitzing, Focal Press.
The Right Way with Flash, L. A. Mannheim, Focal Press.
The Hobby Flash, Walther Benser, Fountain Press.

4 · Choosing a Film

There are three basic categories of film from which a choice has to be made before loading the camera. They are

(1) *Monochrome film*, which produces black-and-white negatives from which unlimited prints can be made by contact or enlargement. The only exception in this category is diapositive film, which can be processed to a black-and-white transparency instead of a negative. This is used mainly to copy diagrams for educational and commercial purposes and offers no advantages for normal photography.

(2) *Colour negative film*, which produces a negative in complementary colours from which unlimited colour enlargements can be produced. Black-and-white prints can also be made from colour negatives with special panchromatic printing paper.

(3) *Colour reversal film*, which produces positive transparencies in colour. These have to be viewed by transmitted light or through a projector and this could be a disadvantage, but the quality of the colour can be far superior to anything obtainable in a print which has to be viewed by reflected light. Duplicates, if required, have to be made by means of an intermediate colour negative and this is necessarily rather expensive. Colour prints can be made in the same way but there is inevitably a slight loss of quality.

Monochrome films

All modern black-and-white films are panchromatic, which means that they are colour sensitive and, to a large extent, translate colours into tones of equivalent strength. The only

exceptions are films made for special purposes, mainly commercial or industrial, and they do not concern us here.

The characteristic that concerns us most is that of sensitivity, popularly known as speed. Some film emulsions are very much more sensitive than others and one might well ask why anybody uses the slower films rather than using the fastest for everything. The principal reason is that slower films give better resolution as a rule.

The resolving power of an emulsion is a measure of its activity to render fine detail, and this should not be confused with sharpness. A negative can look sharp and yet not show so much detail as another. Sharpness is identified by the suddenness or otherwise of the transition between dark and light tones. Thus a negative of a subject such as a checkerboard will *look* much sharper than one of a misty landscape. As a general rule, the slower the film, the better the resolution, other things being equal.

Another characteristic of a monochrome emulsion is graininess. Properly exposed and developed, the slower films do not show grain except under a considerable degree of magnification. Fast films tend to show grain even when developed in so-called fine-grain developers, but modern emulsions have been improved to a point where it only becomes obvious in quite a big enlargement. This graininess, however, is not caused by individual grains of silver halides suspended in the emulsion but by agglomerations or clumping of the grains. This tendency to clumping is greater in fast films than in slower types, although it can be controlled by keeping down the energy of the developer, as we shall see in a later chapter.

There have been a number of different methods of expressing the sensitivity of a film, but only three are in common use today. They are Gost, DIN and ASA. The Gost system is used only in the USSR and some of the satellite countries, so it need not concern us here. The DIN system (Deutsche Industrie Norm) is used in Germany and some other European countries, but in Great Britain, America and, indeed, almost everywhere else in

the world the ASA system is used. This is a standard of the American Standards Association and it is uniform with the BS system (British Standards Institution) which is sometimes quoted.

Another system known as Weston, which is used on Weston exposure meters, is also based on ASA figures, but it is important not to confuse the modern Weston system with the old one that is still found on earlier models. The figures on these are about half of ASA speeds.

ASA speeds are arithmetical. In other words, a film quoted as ASA 50 is half as sensitive as one marked ASA 100 and will require twice the exposure.

Only the ASA, BSI and Weston speeds are strictly comparable because the other systems are based on different parameters, but the following table of typical film speeds in use today will serve as a guide. Scheiner speeds, an older German system, are also included because there are still many cameras in existence that are marked with this system.

ASA	DIN	Gost	Scheiner
10	11	9	22°
25	15	22	26°
32	16	28	27°
50	18	45	29°
64	19	56	30°
100	21	90	32°
125	22	110	33°
200	24	180	35°
400	27	360	38°
800	30	720	41°

Monochrome films of a lower sensitivity than 100 ASA are broadly classed as 'slow', while those between 100 and 300 are called 'medium-speed' films. The range above 300 and up to

800 ASA are classified as 'fast', while anything above 800 ASA is 'ultra-fast' or 'super-speed'.

The most popular films for general use are those between 100 and 200 ASA. Although called medium speed, they are more sensitive than the very fastest were a few decades ago. They show very little grain when developed in a suitable developer and enlargements up to almost any size are possible. They give good gradation and contrast, and the speed is sufficient for ordinary use.

The fast films are usually reserved for such special purposes as press work or high-speed action subjects where it may be necessary to give short exposures in very poor light. To a press photographer, in particular, getting a picture is more important than grain. In any case, prints are rarely required larger than 10 in × 8 in and the half-tone screen used in reproduction 'kills' most of it.

Negatives of fast films tend to be rather soft, especially when developed in fine-grain developers containing a lot of restrainer, and this means printing on hard or contrasty papers which can emphasise grain. Fast films also tend to be a little oversensitive to red; this means that they do not translate colours into monochrome tones quite so accurately as medium-speed films, which nowadays are very good indeed. This is not important with many subjects but it is noticeable in portraiture, where flesh tones and lips tend to be rendered too light.

Monochrome films slower than 100 ASA are usually reserved for special purposes such as copying or record work where the camera is used on a tripod and the extra contrast and resolution is an advantage.

Laymen sometimes wonder why keen amateurs still use black-and-white films when colour has become so easy and so good. The principal reason is that the enthusiast can exercise so much more control. By using various filters at the taking stage he can dramatise a subject and interpret it in his own way instead of just making a record of what is in front of the camera. In the darkroom he can carry this further: select special areas for

enlargement, print several negatives together, modify tones by shading, or employ one of the various allied printing processes such as tone-separation, solarisation or bromoil.

These facilities and dodges enable him to remove the picture even further from reality than a two-dimensional, monochrome picture is already. In addition, he has all the fun of doing everything himself, from taking to printing—something that is not nearly so easy in colour work.

Colour negative films

These are films that, like black-and-white, produce negatives from which positive prints can be made but in colour. In these not only are light and shade reversed but also the colours themselves appear as complementaries. For example, blue appears as minus blue, which is yellow; green as minus green, which is magenta; and red as minus red, which is cyan.

Unfortunately, it is difficult to assess the colour quality of most colour negatives because they have an overall yellow or orange appearance due to colour 'masking'. This is incorporated to overcome the imperfections of some of the dyes that absorb some of the colours that they should transmit.

Colour negative film can be processed by commercial finishing houses through dealers or chemists and, in most cases, can also be processed by the user. It takes a little longer but can be done in the same tanks as black-and-white film. It has to be loaded in the dark, but the rest of the processing can be done in daylight or artificial light. The special kits of chemicals make it very easy, but once mixed they do not keep for long, so it is only economical to process colour negatives at home when you have about six rolls to process.

An advantage of negative film over reversal film for transparencies is that the amateur variety can be used in a wide range of lighting without the necessity for correction filters to ensure accurate colour balance. The correction, if necessary, is done at the printing stage.

Most colour negative films are in the speed range of 50 ASA to 100 ASA.

Colour reversal films

These are films that yield positive transparencies that have to be viewed by transmitted light. In some countries they are called diapositives, and when mounted for projection they are usually called slides. The great advantage of these films over the colour negative and print process is that a very much greater range of brightness is possible. In a print it rarely exceeds about 30:1, but in a transparency the range can be as great as 5000:1. The result on projection is a brilliance that is often described as breathtaking.

The main disadvantage of reversal film is that it is a 'one-off' process. If duplicates or prints are required it is necessary to make an intermediate colour negative, which is expensive and also involves some loss of quality.

Most reversal films have to be returned to the manufacturer for processing, but there are a few that can be processed at home or by a laboratory. As with colour negative films, kits of chemicals can be purchased for the purpose, but they also have a short life after mixing and are not economical unless about six films can be processed within a few days.

The reversal films that have to be sent back to the manufacturers are sold in this country inclusive of processing, and the 35 mm and 126 size films are returned in 2 in × 2 in card or plastic mounts ready for projection.

The colour balance for reversal film cannot be altered during processing and has to be balanced for a specific colour temperature during manufacture. It is therefore sold in two types, one called Daylight and the other Type A. The Daylight type is balanced for a colour temperature of about 5500 Kelvin, which is roughly equivalent to the lighting at noon by diffused sunlight. Type A is designed for use with the overrun lamps called photofloods, which burn at a colour temperature of about 3400 K.

There is also a Type B film, but this is intended for professional studios using tungsten lamps, which burn at a colour temperature of 3200 K.

An enormous range of correction filters is available and these enable extremely accurate colour rendering to be achieved under almost any lighting conditions. However, the Daylight type and the Type A are sufficient for most purposes without the use of filters. The purist or the scientist may want to make a sunset look like a midday shot because the latter shows the *basic* hues, but most people will want a sunset shot to look like a sunset and the additional warmth of the lighting will be regarded as an asset rather than a drawback.

Many people use the daylight-type film all the time because flash gives perfectly good results with it. However, it cannot be used for photoflood lighting or normal artificial lighting without using a correction filter such as a Wratten 80B. This does not give very good colour rendering, and if a lot of photoflood work is contemplated it is better to use Type A and then add a filter, such as the Wratten 85, for daylight shots. This gives better results in terms of colour balance and there is no great loss of speed caused by the filter factor because Type A film has a higher speed than the Daylight type.

It will be seen from this that it is not possible to mix lighting of different temperatures. If, for instance, Type A film is used for portraits by photoflood lighting, it is essential to ensure that windows are curtained or they will come out much too blue.

Colour reversal films are available in quite a wide range of speeds—from 25 to 500 ASA. However, the higher speeds are not achieved without a very considerable loss of quality in colour balance, colour saturation, definition and grain. Those rated at speeds of 25, 32, 50 and 100 ASA have achieved an extraordinary standard of accuracy and colour brilliance, but above 100 ASA they begin to fall off and should really be reserved for emergencies when speed is all important.

Infra-red films

There is one other category of film that interests amateurs for special purposes. This has an emulsion that is particularly sensitive to the red end of the spectrum and, in conjunction with a filter passing only infra-red rays, unusual effects are produced.

Many things, especially foliage, reflect infra-red rays very strongly and thus come out white, or nearly so, the effect often resembling moonlight. It sometimes makes scenery that includes plants, trees and fields look like a snow picture. Blue skies come out black and red or orange objects appear nearly white.

The haze that obscures the detail of a distant landscape is easily penetrated by infra-red, so it is often used for long-distance photography.

The rays from an infra-red filter come to a focus slightly behind the plane on which the equivalent visible rays meet and so it is necessary to make some adjustment to the lens focusing. Many cameras have a dot or arrow to which the lens should be rotated after focusing on the subject by visible light.

Since no exposure meter can measure invisible rays it is difficult to estimate exposure precisely. With an infra-red filter in position the film is comparatively slow—about 20 ASA—so a range of exposures should be made on either side of the exposure indicated by visible light measurement.

There is a version of infra-red for colour and this is called Ektachrome Infra-red Aero film. It reproduces most colours in totally different hues from their appearance in nature. Originally designed for the detection of camouflage from the air in wartime, it has a number of scientific applications, notably in biology, forestry and medicine.

It can only be regarded as an amusing gimmick for amateur work because the results are so unpredictable. Green often appears as magenta, blue as red, red as yellow and yellow as white. It is therefore useless for portraiture but sometimes produces attractive landscapes.

Like monochrome infra-red film, it is not possible to apply an ordinary speed rating because invisible infra-red rays cannot be measured. A deep yellow filter (Wratten No. 12) must be used because all three emulsion layers are sensitive to blue. With this filter Kodak recommends a meter setting of ASA 100 for a trial, but it is necessary to bracket exposures by several stops either way because there is very little latitude. The film can be processed by the user or by a processing laboratory using the ordinary processing solutions sold for the normal Kodak reversal films, and it must be carried out in darkness.

Infra-red films in monochrome or colour are not usually stocked by dealers and have to be especially ordered.

Further reading about flash

The Photoguide to Flash, Gunter Spitzing, Focal Press.

5 The Use of Filters

There are two reasons for making use of filters in photography. One is to correct faults in the lighting or to compensate for deficiencies in the film's response; filters for this purpose are called correction filters. The other reason is to falsify colours or exaggerate contrasts in order to introduce extra impact or drama, and filters used in this way are called contrast filters.

Filters are made of coloured glass or gelatine and placed in front of the lens to absorb light rays from specific areas of the visible spectrum while transmitting the rest. Put another way, it means that a filter freely transmits light of its own colour but absorbs in varying degrees the rays of the other colours that make up white light. Thus a red filter will pass the light from a pillarbox and, in monochrome work, it will come out lighter than it would do without a filter. At the same time the blue sky behind will be partly absorbed, so it will come out darker than is natural.

In normal practice there is very little need to use correction filters with modern black-and-white films. Some of the slow films are slightly oversensitive to blue, and a very pale yellow filter will correct this. Some of the very fast films are oversensitive to red, and a very pale blue filter will restore accurate tone translation. The imbalance in both cases is so small that it can be ignored, except for highly scientific work.

Contrast filters

However, filters are very useful indeed for adding contrast and altering tone values so that an object stands out from its background. In still-life work, especially for commercial purposes, a filter of the right colour can separate objects that would otherwise translate into similar tones and it can also be used to

emphasise pattern or texture. For instance, the grain in a piece of wood can be made to appear much more pronounced than it does to the eye.

The filters in common use with monochrome films are yellow, yellow-green, green, orange and red. As already mentioned, each of these transmits rays of its own colour and absorbs some of the other colours, but in varying degrees. This means that in selecting a filter to darken a particular colour its effect on others must be considered. For example, consider the case of a red-brick building against a blue sky. Without a filter the sky and the building could well come out very similar in tone and the picture would look flat. A red filter would darken the sky very considerably but would probably make the building appear nearly white. An orange filter would also darken the sky and lighten the brick-work, but to a lesser extent. A yellow-green or yellow filter will have even less effect. If there is green grass in the foreground it will probably be lightened by the yellow or yellow-green filter but darkened by the orange and the red filter. The table below gives some idea of what happens, but the easiest way to decide on a filter is to memorise two rules:

(1) *To lighten* a colour use a filter of the same colour, e.g. to lighten a green lawn use a yellow-green filter; to lighten a red dress use a red filter for maximum effect or use an orange filter for a lesser degree of lightening.

(2) *To darken* a colour use a filter of the complementary colour, e.g. to darken a blue sky use a yellow filter; to darken a red pillarbox use a green filter.

Filters of every colour are available in a range of densities—the deeper the colour, the greater the effect, though naturally one has to increase the exposure accordingly because more light is being absorbed instead of transmitted. The increase required is referred to as the filter factor and is written as 2x, 3x, 4x, etc. The figure corresponds to the extra exposure necessary—for example, a 2x filter will demand twice the exposure, or one stop increase, over the exposure required without a filter.

FILTER	Darker	Unchanged	Lighter
YELLOW	Violet, Blue	Green	Yellow, Orange, Red
YELLOW-GREEN	Violet, Blue, Red	Yellow	Green
GREEN	Violet, Blue, Red, Orange	Yellow	Green
ORANGE	Violet, Blue, Green	Yellow	Orange, Red
RED	Violet, Blue, Green, Yellow	Orange	Red

It should be noted that this factor does not have to be applied with a camera that measures the exposure through the lens because it will be automatically taken into account. Automatic cameras that have the electric cell aperture close to the lens will not require adjustment if the filter used is large enough to cover the electric cell window as well as the lens. This often happens with cameras that have the cell actually in the lens mount and close to the lens.

It should also be noted that a filter, however deep, cannot give tone where no colour exists. An overcast sky that has no blue in it will not be affected, even with a red filter. Likewise, a filter is more effective in a clear atmosphere than when it is misty or hazy. This means that a very pale filter used at high altitudes or by the sea on a clear day can have an effect normally associated with a very deep one. People who habitually use, say, a 3x yellow-green filter in Great Britain often find that a 2x or 1½x gives similar results when they go on holiday in semitropical or tropical climes.

Another consideration is the nature of the light. Daylight is

redder in the early morning and late afternoon than it is at mid-day, so a paler filter can be used to obtain the same results. If the filter used is yellow, orange or red, less exposure will be required at the extremes than at noon. Likewise, other things being equal, the filter factor for these colours is reduced when used in photo-flood or artificial lighting other than flash.

Graduated filters

A filter that is graduated from yellow on one side to clear glass on the opposite side is popularly known as a sky filter. If it is placed well in front of the lens, the blue rays from the sky will pass through the yellow part of the filter and those from the landscape will pass unhindered through the clearer half. This type of filter was especially useful in the days when films were very oversensitive to blue at the expense of other colours. Even today it can be useful because skies are usually much too bright in relation to the landscape.

No filter factor is involved, but it is important to ensure that the filter is placed well in front of the lens—at least $\frac{1}{2}$ inch in the case of a 50 mm lens. If it is mounted on the lens in the usual position for other filters, it will merely behave as if it were a pale yellow filter covering the whole lens, and a filter factor will be involved. Some graduated filters are made to fit onto the front of a lens hood, but they must be large enough to avoid any danger of cut-off and it may still be necessary to shield the filter from surface reflections when working against the light or in strong side-lighting conditions.

Blue filters

At one time nearly all films were oversensitive to blue, so yellow, yellow-green or green filters were useful for absorbing some of the blue rays. Nowadays most films are well balanced in their tone rendering and, if anything, are oversensitive at the red end of the spectrum. This applies especially to the very fast and ultra-fast emulsions, i.e. 400 ASA and upwards.

For normal subjects this red sensitivity can be ignored, but

for indoor portraits by artificial light, which is warmer in colour than daylight, it sometimes results in pale lips and wan flesh tones, while blue eyes come out too dark. A pale blue filter will help to correct these faults and to make lips darker and blue eyes lighter, at the same time giving better tone and modelling in the flesh. Unfortunately, it will also emphasise freckles if they are present.

A yellow, green, orange or red filter will penetrate haze to some extent and often give a clear background when it looks quite misty to the human eye. Indeed, with an infra-red filter it is possible to photograph distant detail that is invisible to the human eye.

The artistic landscape photographer sometimes prefers to retain or even emphasise the mist or haze, and a blue filter will do this. It is even possible with a deep blue filter and a degree of underexposure to obtain pseudo-moonlight effects. A deep blue filter is also useful as a 'viewing glass' for indoor work by artificial lighting because it gives an impression of the difference in contrast between that seen by the film and that by the eye. (See Chapter 12.)

Filters for colour work

It will be obvious that the filters designed for monochrome work are not suitable for colour films because they would give an overall cast of their own colour. There are, however, a number of filters that are used to compensate for lighting that is not of the colour temperature for which the film is balanced and there are also a few filters for special purposes.

The first, and the one in general use by all photographers, is the ultra-violet (UV) filter.

This usually has a faint pink or straw colour, and its purpose is to absorb some of the ultra-violet rays and thus check the tendency for colour films to produce rather too much blue over the shadow areas in daylight shots. It also gives a slightly warmer rendering to distant landscapes, mountain pictures,

seascapes and sunlit snow pictures, all of which are rich in ultra-violet.

UV filters are useful when daylight-type reversal film is used with electronic flash, which is rich in ultra-violet. It reduces the danger of flesh tones coming out too blue, especially in the shadow areas. There is no extra exposure required for the UV filters in general use, and since they have no effect on monochrome film they can be left permanently in position over the lens, where they act as a useful protection against scratches and dust.

Colour correction filters

In the chapter on films it was stated that colour reversal films are balanced for a specific colour temperature, and for amateur use there are two types: Daylight and Type A. The former is balanced for about 5500 Kelvin, which is roughly equivalent to overcast noon daylight, while the latter is balanced for photoflood lighting (about 3400 K).

Sometimes it is not possible or convenient to change films when it is desired to switch from outdoor to indoor work or *vice-versa*, so filters are available to enable the same film to be used throughout. When exposing Daylight film by photoflood lighting a blue filter will absorb the excess yellow before it reaches the film. A typical example is the Wratten 80B.

When exposing Type A film by daylight a yellow filter is required to absorb the excess blue and the Wratten 85 is commonly used. Unfortunately, the use of Daylight film with an 80B filter in photoflood lighting involves a high exposure factor —about 4x—and the results are not so satisfactory in colour rendering as those given by Type A film. The latter used in daylight with an 85 filter gives quite good results and, since Type A film is faster than the Daylight type, the filter factor is almost cancelled out. If a great deal of 'mixed' work is anticipated it is, therefore, better to use Type A film rather than Daylight.

Another type of correction filter is one used for Type A films in artificial lighting other than photoflood. A whole series

of bluish filters are available for raising the effective colour temperature when the lighting is too red, as it is with tungsten lamps or under-run photofloods. A colour temperature meter is almost essential to ascertain exactly what depth of filter is required and so colour correction filters of this type are used principally for scientific or recording purposes where absolute accuracy of colour rendering is required.

This also applies to the series of brownish filters that are available to *lower* the effective colour temperature. Colour film manufacturers market filters under their own brand names and numbers; there are too many to describe here, but the Wratten Series marketed by Kodak are typical. The brown filters are known as Wratten Series 81 and the blue as Wratten Series 82. There are five filters in the former and four in the latter series.

At a colour temperature of 3200 K the changes produced by each filter are in steps of about 100 K, but at other temperatures the changes will be different. This is a weakness of the Kelvin scale of expressing colour temperatures and so the Mired scale is more often quoted.

The word Mired is derived from *Micro-Reciprocal Degrees* and a Mired value is the Kelvin temperature divided into one million. Thus a mean sunlight value of 5400 K can also be quoted as having a Mired value of 185. The advantage of the Mired scale is that equal intervals on the scale correspond to equal changes in colour.

The practical advantage of this is that Mired shift values or steps can be allotted to colour filters and they will indicate the change in colour that each filter will produce. This will be the same whatever the initial colour temperature of the light. Yellow filters are given positive shift values, i.e. +9, +18, etc., and blue filters, which reduce the shift values, are designated minus, i.e. −10, −21, etc.

A correction filter called the Wratten 81C may sometimes be encountered. It is designed to enable clear flashbulbs to be used with Type A (photoflood) film. However, nearly all flashbulbs are now coated blue, so this filter is no longer necessary.

Colour compensating filters

These should not be confused with colour correction filters. Colour compensating filters—usually prefixed with CC—are employed in making colour prints from colour negatives and can also be used to effect slight modifications of colour balance when making duplicate transparencies. A full range consists of thirty-six filters—six each of yellow, magenta, cyan, red, green and blue—of varying density. Their use is outlined in Chapter 15.

Polarising filters

A polarising filter provides a means of controlling specular reflections from polished surfaces. It will reduce or even extinguish light falling on it that is polarised in any plane other than its own. By arranging the filter in a mount that permits rotation it is possible to find a position where specular reflections from shop windows, metallic surfaces or highly polished materials are considerably reduced. Complete extinction can be obtained when the polarisation plane of the filter is at right angles to the plane of polarisation of the light.

The filter has to be rotated until the desired degree of suppression is obtained. On a single-lens-reflex camera this can be seen in the viewfinder, but on a twin-lens-reflex or non-reflex type of camera the filter must be adjusted at eye-level and then transferred to the lens mount without changing the angle of rotation in relation to the subject.

The filter is a neutral grey in appearance and it can be used with colour or monochrome films. In colour work it will not alter the basic hues, but it will darken blue skies that are plane-polarised at 90° to the sun; it is often used just for this purpose. Polarising filters also absorb ultra-violet radiation and therefore tend to 'warm up' shadows and open landscapes, seascapes or mountain scenery which are normally rendered too blue.

A bonus given by a polarising filter is a greater degree of colour saturation or brightness due to the fact that all surfaces have a certain degree of specular reflection, and at least some of it will be suppressed by the filter.

An important consideration is the camera viewpoint when a polarising filter is used for suppressing unwanted reflections. To point a camera at a shop window and expect the filter to remove all reflections will only lead to disappointment. The camera will have to be moved around until a viewpoint is found where the filter has the most effect, but it is unlikely that at any point *all* reflections will be eliminated, even if it is desirable.

Polarising filters demand an increase in exposure that varies with the amount of light that is suppressed and it can only be ascertained by experiment, except when using a single-lens-reflex with built-in metering that measures the light actually coming through the lens.

Filter types

Nearly all filters are available in two forms—gelatine and dyed-in-the-mass glass.

Gelatine filters are perfectly satisfactory, economical and optically excellent. They do not affect definition in any way but, of course, they are fragile and once marked with fingerprints or scratches they are useless. They also tend to become cloudy if exposed to moisture.

Dyed-glass filters are considerably more expensive, but if they are to be used frequently they are an economy because they can be handled and cleaned. They are supplied in push-on or screw-in mounts so that lens hoods can be used in conjunction with them. It is a false economy to buy the cheapest because they are often far from optically flat and will introduce distortions or aberrations. In general, it is wise to buy the filters marketed by the camera manufacturer because he is naturally concerned to see that the lens performance is not spoilt.

Further reading about filters

Filter Practice, Hans Clausse and H. Mensel, Focal Press.
Kodak Range of Light Filters, Kodak Ltd.

6 Exposure

Correct exposure presents no difficulties with modern films and apparatus, although it is an aspect of photography that seems to frighten many people. This is probably a hangover from the days when film emulsions were very insensitive or slow and the methods of exposure calculation were, to say the least, primitive.

In the early days of photography exposure had to be precise or the resulting plates were virtually unprintable through being too thin (underexposed) or too dense (overexposed). Today the films have very much more latitude and prints can be obtained from negatives made with a wide variation of exposures on the same subject. However, this can lead to carelessness; the best print will always be the one made from a *correctly* exposed negative.

Colour transparencies have far less latitude in exposure than monochrome or colour negative films because little or no adjustment can be made in processing. A transparency that is underexposed will be dense when projected and one that is overexposed will be too thin. Furthermore, the colours will not be correctly rendered and a slide show made up of transparencies of varying densities and degrees of colour saturation will be unsatisfactory.

Therefore, we should always aim at getting accurate exposure whatever type of film is used and it is wise to forget any question of latitude or, at least, not to rely on it except in emergencies. Fortunately, as we shall see, it is easy to be accurate, but it will help if we understand the four basic factors that are involved.

The first of these is the speed, or sensitivity, of the film and, as we learnt in Chapter 4, this can vary considerably and thus has to be taken into account. Fortunately, the manufacturers

mark their films with a universal standard speed system such as ASA or DIN and they are remarkably consistent. The figure is always given on the film carton, cassette or cartridge.

The second factor is the strength of the light, whether it is sunlight, artificial light or flash. Obviously, the brighter the light allowed to enter the camera for a given amount of time, the greater its effect on the film—this is what makes photography possible. At one time it was also necessary to take into account the nature of the light. For example, when films were far more sensitive to blue rays than anything else, a much longer exposure had to be given for artificial light than for daylight because the proportion of red light to blue is much higher in electric, or tungsten, lighting. Nowadays this consideration is rarely necessary because all but those films made for special purposes are sensitive to all colours in the visible spectrum.

The third consideration is the amount of light that is allowed to reach the film. This is controlled by the iris diaphragm described in Chapter 2. Fortunately, the aperture formed by the iris diaphragm is also on a universal system. This means that any particular 'stop' will permit the same amount of light to pass through any lens regardless of the focal length of the lens. For example, f/8 on a 50 mm lens will pass an equivalent amount of light to f/8 on a 200 mm lens, although the diameter of the aperture on the latter will, in fact, be considerably larger.

The fourth factor is the amount of time during which the light is allowed to reach the film. This, of course, is controlled by the shutter in most cases, but for very long exposures it can just as easily be controlled by taking a cap off the lens and replacing it, or by switching the light on or off. When using flash it is very often the duration of the flash itself that is the controlling factor because it is often less than the time that the shutter is open.

Nevertheless, for most work other than flash the shutter speed is the factor to be considered in exposure calculation. Here again, a degree of standardisation has made calculation very easy. There are two basic types of shutter: between-lens and

focal-plane, but both usually carry speed markings in a progression of: 1 s, 1/2 s, 1/4 s, 1/8 s, 1/15 s, 1/30 s, 1/60 s, 1/125 s, 1/500 s, 1/1000 s. Cheaper models may omit the slower speeds and the very fast 1/1000 sec.

It will be seen that each of these speeds is exactly, or almost exactly, half the one preceding it. We have already seen in Chapter 2 that each f stop on the iris diaphragm is also arranged so that the preceding one passes only half the light of the previous stop; thus by taking the aperture and the shutter speed in combination we have very precise control over the amount of light passed through the lens on to the film.

For example, in the following table all these combinations will give the same effective exposure:

f/2	f/2·8	f/4	f/5·6	f/8	f/11	f/16	f/22
1/1000 s	1/500 s	1/250 s	1/125 s	1/60 s	1/30 s	1/15 s	1/8 sec.

If we presume that any one of these combinations is correct for 100 ASA film, the correct exposures for 50 ASA film will be found by moving the top line one place to the right so that the progression starts with 1/500 at f/2, 1/250 at f/2·8 and so on. Likewise, for a film of speed 200 ASA the correct exposure for the same lighting conditions will be found by moving the top line one place to the left so that it starts with 1/1000 at f/2·8. For film of 400 ASA it would be moved two places to the left.

Thus all we have to do is find the correct shutter speed/aperture combination for the film in use, and all the other combinations are easy to find by turning the aperture and shutter-speed scales on the camera or on the exposure meter in opposite directions.

This leaves us with only the strength of the light as an unknown factor but, nevertheless, the most important one. In the early days elaborate tables were published giving factors for different lighting conditions at different times of the day throughout the year and in different latitudes. These figures were combined with the figures for the speed of the plate, the shutter speed and the aperture, together with filter factors and

other variants. The photographer of the 1850s would have welcomed this decade's electronic calculators!

Exposure meters

Today we have photo-electric exposure meters that measure the strength of the light and they are a most reliable guide if used properly. They are often built into the camera and some of these are coupled to the shutter mechanism or diaphragm. In automatic cameras they even open and close the diaphragm for you. Other meters are completely separate and the information obtained from them has to be transferred to the camera's diaphragm or shutter-speed dial, or both, by the user. There are advantages and disadvantages to both built-in and separate meters.

The big advantage of a built-in meter is convenience, and when coupled to shutter and diaphragm it makes for very quick working. The main disadvantage is that it can only measure the light falling on the camera lens. This may include lots of sky or background which is not so important as the main subject. For example, in an outdoor portrait correct exposure of the face is essential, but the influence of a bright sky might cause the face to be underexposed. It is therefore desirable to take the meter close enough to eliminate the sky and to read only the light reflected from the face. It is not always convenient or practicable to take the camera up to the subject, so a separate meter is an advantage.

There are times, as we shall see later, when it is desirable to measure the light falling on the subject rather than the light reflected from the subject. This especially applies to reversal (transparency) films and it also means that the meter should be used close to the subject and not at the camera position.

A further disadvantage of the built-in meter is that the whole camera is out of action if the meter needs repair, but fortunately this is rare—most meters are very reliable.

There are two types of photo-electric exposure meter. One

Fig. 12 A popular type of exposure meter that will measure over a wide range of lighting conditions. The cell on the back can be masked for extra bright lighting and a white opal cone can be placed over it for incident light readings.

is actuated by a selenium cell which reacts to the light falling on it by producing a tiny current that actuates a pointer or indicator. The other employs a CdS (cadmium sulphide) cell that needs a miniature mercury battery to activate it. This type is more sensitive than the selenium type, i.e. it will give a reading at much lower light levels, so it is usually the one employed in cameras. On the other hand, the selenium cell has a better all-over response which closely follows that of the human eye. Nevertheless, except for one well-known make, the selenium meter is rapidly losing favour, especially as some of the better CdS meters now have a much improved response.

Reflected light reading

Exposure readings for many subjects are taken with the meter pointed at the subject from the camera position. The pointer indicates the strength of the light and scales show the aperture/shutter speed combinations that can be used for the particular speed of film in use. In most cameras where the meter is built in, the film speed is set and the aperture ring or the shutter speed dial can be turned until a pointer coincides with the meter's pointer. Alternatively, they can be coupled to the meter indicator, which is moved by the aperture ring or speed dial until it coincides with a mark visible in the viewfinder.

Taking readings in this way is quite satisfactory for average subjects where there is a fairly even distribution of tones and not too much contrast. The meter can only measure the overall brightness, so we sometimes have to use the meter merely as a guide and then make some commonsense adjustments.

For example, consider an open landscape on a bright sunny day. The sky will be very much brighter than the fields and foreground, so it will influence the meter to indicate an exposure that could be insufficient to get good detail in the earth. This can be overcome by tilting the meter or the camera downwards when taking the reading so that less of the sky, or even none at all, is being seen by the meter. Unfortunately, however, this cannot be done with a fully automatic camera because it will revert to the original setting when the camera is tilted up again.

We have already seen that an outdoor portrait could be very much underexposed if too much sky is allowed to influence the meter and, likewise, a portrait taken indoors or outdoors against a black or very dark background could be *overexposed* due to the lack of light. Some cameras with built-in meters allow for this by having what is known as a 'centre-weighted' reading. Working on the presumption that the centre area of a picture is usually more important than the rest, it reacts more to the rays from the centre of the subject than to the remainder. Failing this, it is necessary to make some adjustment for such subjects by opening up or closing down the aperture or speed indicated by the meter.

There is also the problem of excessive contrast. Often it is desirable to have as much detail and tone as is possible in every part of the picture, from highlight to shadow. Sometimes this will not be possible because the range of tones is greater than the film can accommodate. If the contrast cannot be reduced by using flash or reflectors, it is necessary to decide on what can be sacrificed—the detail in the highlights, the detail in the shadows or a little of both?

If it is to be the highlights, then the reading should be taken from the shadows and middle tones with the meter shielded from the highlights. If it is not possible to shield it, an average reading must be taken and the exposure increased by one or more stops, or a slower shutter speed must be used. On the other hand, if the detail in the shadows can be sacrificed, the reading should be taken from the highlights and middle tones with the meter angled to avoid the shadow areas. Again, where this is not practicable, it will be necessary to compromise by taking the meter reading as a guide and reducing the aperture by one or more stops, or by using a shorter shutter speed.

Where the decision is to lose a little of both highlight and shadow detail an average reading is probably the best, but it is far better wherever possible to reduce the contrast by employing flash or reflectors. Failing that, it is better to wait for more diffused lighting conditions—an overcast sky or a degree of haze.

Another advantage of a separate meter is that one can go very close to the subject and take one reading from the shadows and another one from the highlights. The exposure can then be adjusted to get precisely what is required—highlight detail, shadow detail or a middle-of-the-road compromise. Some of the better meters actually give some guidance on the range of tones that an average film will accommodate, but it is only a guide because film characteristics vary enormously. As a general rule, monochrome films can take in a considerably greater range than colour films.

Some monochrome films can even accommodate a range of tones of the order of about 800:1, but even this cannot cope

with a really contrasty subject on a bright sunny day. Nevertheless, it is very much greater than the tone scale on an overcast day, so quite a wide variation in exposures could be given and each would still be within the capacity of the film. This is why such films are described as having a lot of latitude.

A simple way of appreciating the problem is to think of the capacity of the film to render tones from black to white in terms of a staircase with, say, twenty steps, the bottom representing black, the top being white and all the others intermediate greys in an even progression.

If the tone range of the subject is only the equivalent of five of these steps it can be placed in four positions on the stairs without going off at the top or the bottom. If, on the other hand, the range of the subject is the equivalent of twenty-five steps it will go off at the top or the bottom. If it is at the top (overexposure) detail and gradation is lost in the highlights, and if it goes off at the bottom (underexposure) detail and gradation is lost in the shadows. While the steps or tone gradation in the middle are clearly defined, the tones that are 'off' the staircase will be compressed and not so well separated. Shadows will be a solid black and highlights will be white and burnt out. Therefore it behoves the photographer to be very careful about measuring exposure for a contrasty subject.

A method adopted by some people to get a correct reading for the flesh tones on a face in an outdoor portrait is to use a light grey card or the back of the hand. This saves going right up to the subject and, as long as the light falling on the card is at approximately the same angle and is the same strength as that falling on the subject proper, it is fairly reliable. It is certainly a good compromise if there is some obstruction such as a fence between you and the subject, especially if the latter happens to be a wild animal!

Incident light reading
Sometimes there is an advantage to be gained by measuring the light falling on the subject instead of the light reflected from it.

The meter is directed from the subject position *towards* the camera and a semi-transparent white plastic diffuser, usually in the form of a cone or half a sphere, is placed over the cell window. This gives a general reading that will not fluctuate according to the tones in the subject.

Incident light reading provides correct exposure for flesh tones, so this method is especially useful for portraiture, particularly in colour. Since it concentrates on measuring the highlights, the incident light reading is much more reliable for colour-transparency work.

Exposure for flash

It is not possible to use an ordinary exposure meter for flash, but fortunately it is very easy to obtain correct exposure. There are, in fact, special meters developed for studio work, but they are too cumbersome to be practical for amateur use in addition to being comparatively expensive.

Since the duration of the illumination from a flashbulb or an electronic flashgun is generally somewhere between 1/600 and 1/1500 second, and this is usually less than the time during which the shutter is open, exposure calculation is based on the brightness and duration of the flash alone. This means that shutter speed does not have to be taken into account and the iris diaphragm aperture is the only other concern.

Every flashbulb and electronic flashgun is provided with a table of guide numbers—one for each speed of film. For example, a small bulb or flashcube may quote a guide number of 80 for 100 ASA film. This guide number is merely divided by the distance in feet to obtain the aperture to use. Thus with a subject 10 feet away the aperture to use will be $\frac{80}{10} = $ f/8. If the subject is only 5 feet away the aperture will be f/16, and if it is 20 feet away the aperture should be f/4.

On most electronic flashguns and many of the attachments for firing bulbs, a scale is provided that enables the aperture for any

speed of film at any distance to be ascertained instantly and easily. Naturally the figure can be used the other way if it is desired to employ a specific aperture, say f/5·6. The guide number is 80, so the distance from the subject at which the flash must be fired is $\dfrac{80}{5·6}$ = approximately 15 feet. It must be emphasised that this distance is always that from the flash to the subject and not the camera to the subject. As you will see in a later chapter, it is rarely desirable to have the gun at the camera position. On many continental guns and tables the figures will be given in metres, which means that the guide number is much lower, but it is becoming common practice to give two sets of numbers—one for metres and one for feet—against film speeds given in both ASA and DIN.

The guide numbers are calculated for average conditions and presume that the flash is being used in a properly designed reflector. This is no problem nowadays because reflectors are always built into the gun and flashcubes even have them built into the plastic case. But if a bulb were to be fired without a reflector it would necessitate opening the diaphragm at least one stop.

The guide numbers are also based on their use indoors where there is a certain amount of reflection from walls and ceilings. If used in a large room with dark walls it will probably be necessary to open up by one stop and, if used outdoors at night, even by two stops.

Sometimes it is desirable to soften the flash by placing a diffuser of some sort, possibly one or more layers of handkerchief, over the gun (see Chapter 13). The best way to allow for the light that is lost is to point an exposure meter at a plain wall, take a reading without the diffuser and note the aperture to use at any specific speed that is convenient. Then take another reading with the handkerchief over the cell window and note the increased aperture indicated for the same speed. It will usually be found that one layer of a linen handkerchief requires an increase of about one stop, two layers two stops and so on.

Bounced flash

Guide numbers are based on flash being directed straight onto the subject. Because this gives harsh results and very hard shadows many people 'bounce' the flash off a suitable reflector so that no direct rays reach the sitter. This reflector can be a ceiling or a wall that is light in tone and, of course, should always be white when using colour film otherwise some of the reflector's colour will be cast onto the subject.

There is no precise way of calculating exposure under these conditions, but a rough guide which usually works is to add together the distances from flash to reflector and reflector to subject. The total is then divided into the guide number and the aperture opened up one stop more to allow for absorption.

A more efficient method of employing bounced flash is to use a white umbrella on a tripod with the flashgun fixed to the tripod head so that it is facing the inside of the umbrella. Apart from the fact that this combination is easily deployed in any position relative to the subject, exposure calculation is made easy because the distance from flashgun to reflector is a constant. Once the correct exposure at any given distance has been found it can be repeated with certainty at any time. The variation between the exposure required for this and for direct flash varies with the conditions in which it is used, so it is advisable to make tests in the first place at different apertures. As a guide for starting the tests, the loss by bouncing in this way is rarely much more than one stop.

Synchro-sunlight

This is the name often given to the use of 'fill-in' flash outdoors. On a bright sunny day when the contrast is greater than the film can accommodate, flash can be used to lighten up the shadows and thus reduce the contrast to a manageable degree.

It is important that the flash is not so bright that it competes with the sun or casts its own shadows. This looks unnatural; when used properly it should be difficult to detect that flash was employed at all.

Calculation of exposure must be based first of all on the highlights of the subject illuminated by the sun, together with the shutter speed and aperture read from the exposure meter in the ordinary way. To arrive at the flash-to-subject distance at which the flash will balance the sunlight, divide the guide number by the aperture you have already decided upon. This will light up the shadows too much—in fact, as brightly as the sun is affecting the highlights—so the distance must be substantially increased or the power of the flash reduced.

For colour work it is usually sufficient to reduce the strength of the flash by about one half with one layer of handkerchief, but with black-and-white two layers will probably provide a better picture. In monochrome we have to make use of tones instead of colours to separate one thing from another, so a little more contrast is desirable.

Another method of calculating is to give about one quarter of what would be required if the flash were being used as the main light. Since the strength of light varies inversely as the square of the distance, this merely means doubling the guide number. For example, assume that the exposure given by the meter for the sunlit side of the subject is 1/125 at f/8. The guide number for your flash is 50, but when adjusted to give only one-quarter strength it becomes 100. This means that the flash distance for giving just enough shadow fill-in with an aperture of f/8 should be $100 \div 8 = 12\frac{1}{2}$ feet. However, this may not be the right distance for the camera, so it will have to be used on an extension or suitably reduced with layers of handkerchief.

Many cameras with focal-plane shutters will not synchronise at shutter speeds faster than about 1/60 second, which means that the highlight reading must be based on shutter speeds. On very bright days this can make fill-in flash impossible because the camera has no aperture small enough to match the slow shutter speed on unless a very slow film is used. Also, the shutter speed of 1/60 may not be fast enough to stop movement, so a between-lens shutter which can be synchronised at all speeds is to be preferred for this work. It should be noted that

fill-in flash is the only technique that justifies having the gun on the camera or on the camera/subject axis because this is the angle where it will not cast shadows of its own.

Exposure with filters

When filters are used for black-and-white photography it is necessary when estimating exposure to allow for the fact that most of them absorb some of the light. Most filters have a multiplication factor such as $\times 2$, $\times 3$, $\times 4$, etc. marked on the mount. As a rule, these figures have a built-in safety factor and are more than necessary. They should be treated with reserve because more pictures these days are spoiled by overexposure than by underexposure. When a green or orange filter is employed to put some tone in the sky, the absorption of the blue rays can be completely cancelled out if the exposure is too long. As a general rule, it is safe to work on half the stated factor.

UV or haze filters do not require any increase of exposure either for monochrome or colour, but conversion filters that permit the use of Daylight colour film in artificial light and *vice-versa* have a multiplication factor given by the film manufacturers which should be closely observed.

Of course, there is no need to worry about filter factors on cameras having through-the-lens metering. On cameras that do not have this feature but have built-in meters with the cell placed close to the lens, it is often possible to place the filter over the cell while the exposure measurement is being taken.

Luminosity and exposure

It has already become clear that contrast must be considered when calculating exposure, and there are two factors of contrast involved. The first is the inherent contrast of the subject, which may have a reflection ratio of as much as 50:1 between a black area and a white area, even under flat or even lighting. On the

other hand, a subject such as a chrysanthemum might have a ratio of less than 2:1 under the same lighting.

The second factor is lighting contrast. It is possible to increase the contrast on the chrysanthemum to something like 20:1 or more by using strong side lighting. As we have already seen, the low-contrast subject allows a lot of latitude in exposure calculation, whereas the higher contrast will need more precise calculation.

When a subject with strong inherent contrasts is also given a contrasty lighting treatment (i.e. side lighting with a minimum of shadow illumination) the overall contrast can be as high as 1000:1. This is not only more than the average film can cope with but it is also far more than any printing paper can reproduce. A good print on glossy bromide paper cannot show a range of brightness greater than about 100:1.

In a transparency the range of tones is not so limited and it may exceed 200:1 when projected. This is one of the reasons why a transparency in black-and-white or colour is capable of giving a far more convincing representation of the original subject, especially if this embraced a wide range of contrast, than can ever be obtained in a paper print.

In spite of this, however, accurate estimation of exposure is most important and, where the range of subject contrast is low, it is desirable to pitch it at the lower end of the scale. This will ensure a black-and-white negative that has all the detail but is thin enough to facilitate easy printing or it will provide a colour transparency that has good colour saturation.

Further reading about exposure

Exposure, W. F. Berg, Focal Press.
Successful Exposure in Photography, L. A. Mannheim, Focal Press.
Films: Subject and Exposure, L. A. Mannheim, Focal Press.
Exposure Technique, G. Gordon Bates, Fountain Press.

7 Taking Landscapes

At one time most of the enthusiasts' and professionals' photographs that appeared on exhibition walls were either formal portraits or pure landscapes, and it was left to the casual snapshotter to picture life and action in a candid, natural way whenever the light was good enough.

Today the emphasis is on candour, human interest and action, both with enthusiasts and with beginners. Landscapes are still a popular subject with many, but the style and presentation has changed considerably, especially by the inclusion of figures, and they are less romantic or 'chocolate-boxy'. Nevertheless, the basic principles of approach and of composition are still valid and so worth some study.

The fact that you are reading this means that you want to improve your photographs, and no doubt you occasionally try your hand at landscapes, especially when you are on holiday or travelling to strange places. By landscapes, of course, I also mean seascapes, mountain pictures and street scenes.

There are a few simple rules that will help you to improve any of these subjects. They are:

(1) Choose side lighting or *contre-jour* lighting.
(2) Shoot early or late in the day.
(3) Select any unusual viewpoint.
(4) Use differential focusing.
(5) Add contrast with filters.
(6) Frame the main subject where possible.
(7) Avoid symmetrical effects.
(8) Choose the right format.

The angle of the light

Film manufacturers tell users to stand with the sun behind them. This is a counsel of safety from their point of view but, in fact, it is the worst possible advice. It always gives a picture if the exposure is anywhere near right, but the result is dull and flat, lacking in contrast and shadows.

It is only when the sun is to the side of the subject that we begin to get form or modelling and, in the case of a landscape, this means separation of planes. Without this separation a landscape will have little impression of depth. The more acute the angle of the light, the greater the contrast, until we reach a point where the sun is actually facing the camera—the reverse of what the film manufacturers tell you to do. This lighting, known as *contre-jour*, gives an outline of light to each separate plane and is most attractive; but it does have problems in exposure, which is why it is not recommended for snapshotters, who are the biggest buyers of film.

Incidentally, the sun does not have to be shining. Even when obscured by cloud or completely diffused by mist, the light is still directional and it is then even more important to ensure that it is to one side of the subject because the shadows will not be so obvious—and it is shadows that help to make a photograph, especially in monochrome.

The nature of the light

The advice to shoot early or late in the day is given for two reasons. First, the shadows are longer and more interesting and, secondly, the light is much warmer. In colour photography the warmth produced by early morning and late afternoon daylight is very pleasing and provides an overall patina which gives unity to the picture. All too often, a landscape taken around midday will be sharply separated into a warm green foreground and a cold blue sky so that there is little to hold these areas together. An overall warmth provides the answer.

Of course, there are times when it is quite impossible to take

pictures during these hours, especially when travelling, and the only answer is to use as many as possible of the other dodges that help to turn a mundane scene into an impressive picture. Sometimes, if the weather is bad, this is easily done. Storm clouds, heavy rain with lots of reflections, snow, frost and mist all provide much more drama than an open sunny scene, so the camera should never be put away just because the sun has disappeared.

Many beautiful pictures have been made as a result of rays from the sun breaking through heavy clouds to spotlight a cottage or a field of buttercups; others have been made by pointing the camera downwards and picturing the reflections in a rain-soaked pavement—the possibilities are endless.

Choosing the viewpoint

Most landscapes are viewed from eye-level, and modern miniature cameras are used at this level. The result is that thousands of pictures are no more than a record of what the eye is used to seeing. Photographs taken from an entirely different viewpoint are much more impressive, and before making an exposure it is a rewarding exercise to kneel down, or even lie down, to see what the subject looks like from there. A very low viewpoint often makes it possible to keep the horizon low in the picture and to use the sky as an attractive but unfussy backdrop to the trees or whatever constitutes the main subject. You are thus presenting the viewer with a new and personal angle on a familiar subject.

Low viewpoints usually give an added impression of height and dignity to the subject, and this applies especially to people in the picture. On the other hand, buildings will have converging verticals, and this should be avoided unless they converge so sharply that it is obvious that this was deliberately done in order to introduce a dramatic note.

Sometimes a subject can appear more interesting when photographed from above rather than from below. This applies mostly in the mountains when it is desired to show a river winding its

way through the valley or a village nestling under a massif. An advantage of shooting down on this sort of scene is that one can eliminate the horizon and the sky altogether, thus avoiding problems of contrast or colour imbalance.

Differential focusing

A good impression of depth or three dimensions is the aim of most landscape photographers and one way of obtaining it is to make use of the lens diaphragm to obtain varying degrees of sharpness on different planes.

On most open scenes exposure is less than average, so there is a tendency to use small apertures. This, coupled with the fact that the camera is focused on infinity or at least a substantial distance, means that the depth of field is great enough for everything from foreground to horizon to be pin-sharp. For record work or picture postcards this may be desirable, but for an artistic presentation it is not.

Therefore it is better to select the plane that is the most important in your opinion and to focus on that. Then select an aperture to give you the degree of unsharpness in the foreground or the distance, or both, that looks attractive without losing identity of detail. This is easy with modern cameras and especially with single-lens-reflex models that have a pre-view button.

To summarise, it is nearly always better first to select the aperture to give the right effect and then to adjust the shutter speed to match rather than *vice-versa*. It is interesting to note that the early landscape photographers who employed differential focus usually had the foreground sharp and other planes getting progressively softer towards the far distance. It was considered undesirable to have the foreground out of focus, but today it is quite acceptable up to a point and many people concentrate on a sharp middle distance or a plane somewhere between the foreground and middle distance. This is good advice when the foreground is a 'frame' for the distant scene, for example an archway or avenue of trees, but when the foreground

is the principal object, as it might be in the case of a cottage or a yacht, then that should be the point of focus. These are instances where the background can be kept well out of focus.

Contrast filters

Photographing a landscape in black and white looks deceptively simple, but often the results do not look anything like so attractive as the original scene. The colours that were clearly defined to the eye often translate into similar tones of grey, clouds are missing and the print looks flat and monotonous. Red poppies that stood out against a green background are now hardly visible and the variety of greens in the trees and bushes has dissolved into solid masses of similar tones.

The remedy for this lies in the use of filters. We have already learnt in Chapter 5 that a filter of coloured glass or gelatine placed over the lens will absorb its own colour and darken others. So if a yellow-green filter is used it will lighten most of the greens but darken the blues. Thus if there is any blue in the sky it will produce a tone dark enough to make the clouds stand out. As the trees, grass and foliage are often a mixture of yellow-greens and blue-greens, the filter will also help to separate them. In particular, it will lighten grass and this is usually an advantage.

All this is really just restoring what the eye separated by colour in the first place, so ideally we want to use stronger filters in order to exaggerate or falsify the tone values. For this reason the landscape photographer would do better to invest in a 3x or 4x filter rather than in one of the lighter ones and the enthusiast will even use an orange or red filter. The latter should be used with reserve because it can make a sunny scene look like a threatening storm, but there are occasions when it might be justified for the sake of impact.

Framing the subject

In most cases the eye is attracted to the lighter parts of a picture first, provided that the darker areas do not contain strong

intrinsic subject interest. It is helpful to take advantage of this by concentrating the lighter tones in the centre of the picture space and having the darker tones towards the edges—in other words, to 'frame' the principal area and thus direct the viewer's eye to it.

Fig. 13 The eye is always attracted to the lightest part of a picture, so the right-hand diagram holds the eye in the picture much more than in the left-hand diagram. It also produces an illusion of depth.

This is very easily done in landscape pictures by shooting through an arch or doorway, through a window or the bars of a gate, or even through the legs of a horse. A very effective frame is achieved by finding a viewpoint where trees provide dark tones at the sides and overhanging branches provide some tone across the top or part of the top. With side lighting this often means that a shadow of one of the trees will provide a dark tone

across the bottom of the picture space, thus completing an all round border of dark tones.

Framing like this produces a sort of peephole effect that gives luminosity to the scene beyond and it is particularly good in colour transparencies. It also helps to give a better impression of depth. It is not necessary as a rule to have the foreground critically sharp and, in fact, it is better to have it a little out-of-focus, though not so much that it is unpleasantly 'woolly' or even unrecognisable.

Fig. 14 Fig. 13 in practice. It is usually possible to find a tree, a doorway, a window or some near object to 'frame' the principal object. A small aperture may be necessary to keep both in focus, but the foreground need not be pin-sharp.

Avoiding symmetrical effects

A landscape that is symmetrical either in tones or in the arrangement of its component objects usually has a feeling of monotony. Imagine a serene and peaceful landscape with all the lines of clouds, hedges, etc. going horizontally across the picture. If the horizon line is halfway up the picture space and, worse still, goes right across without a break, the effect will be of a picture neatly halved. The horizon, with very rare exceptions, should always be well down or well up in the frame.

In terms of tone it usually takes a much larger area of light tone to balance a given area of dark tone and therefore, more often than not, it is better to keep the horizon low so that the

Fig. 15 The composition shown on the left is too symmetrical.
The right-hand sketch shows a more interesting design with
far more movement.

area of sky is greater than that of the darker landscape. This
applies both to colour and to black-and-white. The greater the
difference in tone values, the lower the horizon will need to be,
other things being equal.

However, even with a good tone balance, such a picture may
still look symmetrical or even monotonous unless an opposing
line is introduced to break the continuity of the horizontals. This
can usually be done by including a tree and choosing a view-
point where it is well away from the centre. It is also important
to avoid including two trees or any other objects of equal size

Fig. 16 Street scenes, avenues of trees or any subject having
obvious vanishing lines should preferably be photographed so that
the meeting point is well off-centre. This is simply a matter of
standing to one side or the other instead of in the centre of the
road. When one side is in shadow, make that side the smaller area.

in such a way that they appear equal in size and equally spaced out in the picture frame. It is usually possible to find a viewpoint where one tree will appear larger than the other and that one should then be nearer the centre to achieve a good balance.

Another type of picture that can so easily look very symmetrical is the one that looks down the centre of a street or an avenue of trees. When both sides are evenly illuminated and the 'vanishing point' comes right in the centre, the effect is rarely as good as it might be. A viewpoint that brings the vanishing point well down in the picture space and well to the right or left of centre is likely to look much more interesting.

To photograph a house or a bridge 'square-on' so that the main lines are horizontals and verticals is not as pleasing as to take a viewpoint to one side where form and perspective comes into play and some of the lines take a diagonal form. The former always have a static look, but diagonals have movement and therefore greater attraction.

Choosing the format

The shape of the picture can have some influence on the mood of a landscape photograph, so it is wise to give some thought to this before taking. A peaceful landscape scene made up largely of horizontals will have the mood emphasised by a horizontal format, but an upright format will tend to oppose the impression of serenity. Even more impact will be obtained by using a much longer horizontal format than the conventional picture proportions.

On the other hand, a dramatic landscape with tall trees or a stormy sky may well look much better in an upright format. Here again, the effect can be considerably increased by trimming to a narrower than conventional upright shape. This can be quite dynamic for tall trees, church towers and skyscrapers.

If you study landscapes that appeal to you it is probable that many of them will conform in a large degree to the basic guidelines of composition set out in this chapter, but there will also

be the occasional picture that breaks every rule and yet has great emotional appeal. However, this is usually because of a powerful intrinsic appeal in the subject matter and further examination often shows that the composition is quite orderly. Composition, after all, is only organisation of all the elements into an ordered or logical arrangement.

Memorise and practise the eight 'rules' given at the beginning of this chapter and your landscapes, seascapes or travel pictures will undoubtedly be far more satisfying than ever before.

Further reading on landscapes

Natural Light Photography, Ansel Adams, Model & Allied
Publications Ltd.

8 Action Pictures

Modern cameras and fast films have made it feasible to photograph high-speed action and to make candid pictures of people almost anywhere. This has made it possible for camera owners to augment their interests in various sports by making photographic records.

It is not always desirable to 'freeze' the action completely and often it is preferable to show a little movement. For example, a racing car that has every detail clearly defined will look as though it had stopped and posed for the camera, but if the wheels are blurred and the spokes indistinguishable it will be obvious that the car was travelling. Therefore the selection of shutter speed is all important.

Consideration must be given to three factors:

(1) The angle of travel in relation to the camera.
(2) The distance from the camera.
(3) The speed at which the object is travelling.

It is easy to appreciate that a subject that is moving towards the camera will require far less exposure to 'stop' the movement than when the same subject at the same speed is travelling directly across the field of view, i.e. from left to right or right to left and parallel to the film plane. The relative amount of movement on the film is much greater in the latter and, while the former may need an exposure of about 1/125 second, the movement across the picture may require at least 1/500 second. Moving objects at angles in between will require corresponding adjustments to get similar results in the print. The nearer they are to a right angle with the camera, the slower the speed required, and the nearer to a parallel with the film plane, the shorter the shutter speed must be.

It would be easy to make a table of shutter speeds for different subjects if it were not for the fact that the distance from the camera also makes a big difference. The nearer the object is to the camera, the larger the image on the film and therefore the greater the movement, other things being equal. For example, an athlete 100 yards away may take 1 second to cross the field of view in your camera and he will be only about ¼ inch high on a 35 mm negative, so a shutter speed of 1/125 second could arrest most of the action. However, if he were only 5 yards away, he would be almost filling the negative and taking only about 1/125 second to cross the picture space, so a shutter speed of 1/500 or even 1/1000 second might be necessary.

Finally, the speed of the object itself must be considered. It is obvious that a car travelling at 100 miles/h is going to need a much shorter exposure than a cyclist at 30 miles/h if both are travelling at the same angle and at the same distance from the camera. Likewise, the cyclist will need a shorter exposure than a runner doing 9 miles/h, and he in turn will need a shorter one than a pedestrian at 3 miles/h.

Very often, even with the fastest films and lenses, one has to compromise. If a moving object under the prevailing light conditions is going to demand a faster shutter speed than is provided on the camera, then the angle must be changed until it becomes possible at the fastest speed available. For example, at a race track it might be impossible to stop the action of cars going past, but swinging the camera to look along the track and to picture them approaching from a distance could save the day. Without a long-focus lens this may mean smaller images on the negative, but at least it will be an acceptable picture, where otherwise only a blur would have resulted.

Experience will enable the user to judge the right shutter speed at any angle and any distance for any subject, but the table below provides some approximations that a beginner could use as a starting point for experiment. It is based on using a 2 in (50 mm) focal-length lens and will provide negatives sharp enough for a 3x or 4x enlargement. Small areas that are

moving faster than the body, such as the spokes of a car or the feet and hands of an athlete, may show some blur, but this is a good thing.

| | | | Shutter speeds | | |
Subject	Speed miles/h	Distance from camera ft	Moving towards camera	45° to camera	Across picture
Pedestrians	3	30	1/30	1/60	1/125
Cyclist	9	30	1/125	1/250	1/500
Horse galloping	15	30	1/250	1/500	1/1000
Train	30	100	1/125	1/250	1/500
Train	60	100	1/250	1/500	1/1000
Racing car	100	100	1/500	1/1000	1/2000

As a rough guide, the speed can be doubled at double the distance, i.e. 1/250 at 100 feet would be 1/125 at 200 feet.

Panning with the action

A technique used successfully by many sports photographers is known as panning. This involves pre-focusing on a spot, such as the middle of a race track, where it is known that the subject will appear. The camera is held with the shutter almost on the point of triggering, and as soon as the front of the object comes into the viewfinder the camera is swung smoothly in the same direction, keeping the object in the viewfinder while making the actual exposure.

This technique enables a slower shutter speed to be used, which is very useful in extreme conditions. It also blurs the background so that the object stands out well, and if there are any highlights in the background they will appear as horizontal streaks, which considerably heighten the impression of speed. With focal-plane shutters a certain amount of distortion occurs

Plate 1 A travel holiday picture which is invested with some drama because it was taken late in the afternoon when the sun was low. A yellow-green filter added tone to the sky.

Plate 2 Two ways of printing from the same negative. One with a short exposure on contrasty paper and one with a normal exposure on soft paper.

Plate 3 Two pictures showing widely different approaches but both having more atmosphere than the average snapshot. The shot of Revieulx Abbey was taken in winter just as a shaft of weak sun struck the centre of the ruins. It shows the value of 'framing' a highlight with darker tones. The aircraft shot has impact because of the sheer simplicity of its design, and this is appropriate to the subject.

Plate 4 Orange, red and infra-red filters have the power of penetrating haze. The top picture was taken without a filter and the lower one with a deep red filter.

Plate 5 This picture, taken on infra-red film with an infra-red filter, has an attractive aura because of the unreal tone values. It emphasises the value of getting away from 'picture postcard' realism.

Plate 6 Portraits of babies are easier to take outdoors because they usually act more naturally. If the sun is bright, shoot against the light. The faces of mother and child have reflected light onto each other. Note how the fussy background has been kept well out of focus.

Plate 7 Outdoor portraiture benefits from late afternoon sun, which has less contrast and gives more atmosphere. The upper picture shows the use of scenery to provide a 'frame' for the subject, but in the lower picture this was not necessary because of the dark background—a hedge well out of focus.

Plate 8 Male portraits are often better for being taken in natural environments, but it is important to avoid a lot of fussy detail and patches of highlight as seen in the bottom left example. The top left picture, taken by flash, shows the danger of pointing it at a reflecting surface. The top right picture looks rather obviously posed, but the bottom right-hand shot makes a virtue of this by getting the subject to look at the camera.

Plate 9 A holiday photograph which anyone can take. Exposure was 20 seconds at f/11 and it was made just before the sky got completely dark. This is Mont Orgeuil in Jersey, which is floodlit in different colours so that it makes a good colour shot as well.

Plate 10 Flash can be used for portraits at night. The camera must be placed on a tripod and sufficient exposure given for the background before the flash is fired.

Plate 11 Domestic pets are easy to photograph with flash, but it should never be on the camera otherwise texture rendering will be lost and the eyes will show a glare or red colour if the animal looks into the lens. This was taken with flash bounced into a white umbrella.

Plate 12 High key lighting is only suitable for a fair-haired subject and dark clothing must not be worn. Bounced flash is ideal for high-key work.

Plate 13 Daylight from a window, preferably facing north, gives superb modelling. Contrast is easily controlled by filling in the shadows with a reflector, flash or photoflood.

Plate 14 Bounced flash gives a similar softness to that
produced by the daylight in the previous picture. The edges
of the shadows are not defined and it is a suitable lighting
for glamour subjects and babies. This was taken with one
flashcube in an umbrella reflector and no fill-in was required.

Plate 15 Lighting from photoflood lamps in polished reflectors gives sharply defined shadows and is generally more suitable for low-key subjects and character portraits. It can also be used for dramatic effects, and this should be compared with the two previous pictures taken by daylight and by bounced flash.

Plate 16 Texture screens, sandwiched with the negative in the enlarger or placed in contact with the bromide paper, can provide interesting variations. They also tend to soften the image and break down detail. This was made with a Paterson canvas screen.

and wheels may come out as ovals. This is also helpful if it is not too exaggerated.

The right moment

In sports or other activities where the participants change direction it is possible to use much slower shutter speeds. A jumper leaping into the air must come down again, so there is a tiny fraction of time when he is poised to change from an upward to a downward movement. Catching this precise moment requires a little intelligent anticipation and the shutter button must be pressed in advance almost to the point of release. Fine pictures of children playing leapfrog, of ballet dancers, steeple-chasers and high jumpers have been captured in this way.

An important point to consider is the fractional time delay between seeing the action and the film being exposed. The message must be relayed from the eye to the brain and from there to the finger on the button. Add to this the time taken for the camera mechanism to open the shutter blades or release the focal-plane curtain and there is sufficient lapse of time to lose a really fast-moving shot, so the action must be anticipated, especially with single-lens-reflex cameras.

Incidentally, it is also important to avoid shooting when it may distract a player. The golfer ready to putt to win at the 18th hole will not appreciate the clunk of a shutter at the critical moment, nor will it help to get in his line of view!

People in action

In addition to picturing sports, there are innumerable occasions when it is desirable to photograph people at work or just walking along the street. Holiday and travel pictures, for example, would be dull indeed without some human interest. The same considerations of angle, distance and subject speed apply, although there is rarely enough time to consider them in detail.

It is a good rule, therefore, to use the fastest film possible and

to carry the camera pre-focused on a suitable distance with the shutter set to a speed no slower than 1/250 second. The aperture should also be pre-set according to the prevailing light conditions to match that shutter speed. The camera can then be brought into action instantly. It may not always come off, but this way there is a good chance of getting something before the subject has disappeared. Press photographers who have to seize as many shots as possible, often in a few seconds, always use fast films, even on the brightest days.

Nowadays grain is so fine even on fast films that the advantage of medium-speed films is not as great as it used to be and the ability to use fast shutter speeds for this sort of work far outweighs the question of grain. In any case, the screen in a newspaper reproduction will kill the grain but, properly processed, it should be possible to get virtually grain-free enlargements from 35 mm negatives up to about 15 in × 12 in.

Composition

The composition of a sports picture or of people in action is probably less subject to 'rules' than the more conservative or static type of subject. With many sports it is desirable to set the scene by including enough background to tell the story. This could mean including the crowds in the stands at a cricket match, the scenery on a golf course or the pier behind children playing leapfrog on the beach. In such cases the principal objects are comparatively small in the picture space and the normal requirement of good balance will apply, but it is the subject rather than design that is more important in an action picture.

The main subject should preferably be somewhere off-centre and preferably light in tone against a darker background so that the eye is held in the picture. Sometimes it may be necessary to shoot from a high viewpoint to achieve this and a horizon cutting across the subjects should be avoided at all costs.

However, it is always a good idea whenever possible to get some close-up pictures as well. Here the design demands more

consideration. If the action is up and down, i.e. a high jumper, a player serving at tennis or a horse clearing a hurdle, the illusion of speed and drama will be considerably emphasised if a low viewpoint is chosen. The subject then appears against the sky or a stand full of people, preferably a little out of focus.

If the subject is travelling towards the camera it is an advantage to have it at an angle rather than upright or horizontal

Fig. 17 An obvious diagonal in the composition always gives a powerful sense of movement, just as a runner leans forward when in action.

because diagonals always suggest movement. This can often be done by choosing a viewpoint near a bend where a motorcycle, cycle or runner will be leaning over. Failing this, it is sometimes possible to get the effect by tilting the camera, provided that there is no horizon or other line to give the game away.

When the subject is travelling across the picture a diagonal line is often formed naturally because a human being leans forward to run. In the case of racing cars, speedboats, etc., there is no diagonal formed, but the impression of speed can be

increased by using a long horizontal format and avoiding any vertical lines in the background.

A similar consideration applies to vertical movement. One of the best pictures of a pole-jumper that has ever been published was taken from a very low viewpoint and then trimmed so that it

Fig. 18 When a picture has a number of opposing diagonals the feeling of fast movement is sometimes reduced, but a powerful impression of vitality can take its place.

filled the whole depth of a newspaper page but only two columns wide. He appeared to be 20 feet up instead of 12 feet!

Some people say that when the movement is going across the picture there should be more space left in front of the subject than behind so that there is space for the object to move into.

Others say the reverse and that if, for example, the nose of a greyhound is almost touching the edge the impression of speed will be increased. Both can be right—it depends on the subject and the other elements in the picture.

Further reading

My Way with a Camera, Victor Blackman, Focal Press.
The Leica Manual, D. O. Morgan, Model & Allied Publications.
Camera Under Water, Horace Dobbs, Focal Press.
Camera Afloat, H. S. Newcombe, Focal Press.
Camera on Safari, John Sherman, Focal Press.

9 Outdoor Portraiture

Daylight is a great aid to natural portraiture whether the sun is shining or not because the fast shutter speeds that can be used will reduce the possibility of movement. Also, a self-conscious or timid subject will always feel easier outdoors, especially if he or she is given something to do.

It is essential to avoid formal posing, which is more suited to a studio and looks unnatural in an open-air setting, but this is one of the most common errors made by beginners. How often one sees somebody being told to 'stand still and look at me', perhaps in front of a dramatic landscape or a beautiful building! A better characterisation would result from letting the subject of his own accord look into the distance or up at some feature of the building. And how much better it would be if he were walking into the picture instead of standing as erect as a wooden soldier.

Common errors

However, strange as it may seem, more outdoor portraits are spoilt by the choice of background than by poor treatment of the subject. Unfortunately, the tiny viewfinder on most modern cameras does not show the background so clearly as the large screen on older cameras used to do. In the case of a single-lens-reflex camera the user is even less conscious of the background because he is viewing at full aperture, so the background might appear well out of focus on the screen. The fact that it will be much sharper at the smaller taking aperture is not realised. Some cameras have a 'pre-view button' that enables the exact effect at the chosen aperture to be seen before taking, and it is

useful to get into the habit of employing this before making the exposure.

The most common error in backgrounds is fussiness. It takes many forms, but its effect is always to attract too much attention away from the subject proper. One of the worst examples is a brick wall, which provides a severe pattern of lines entirely out of keeping with most people, except perhaps a bricklayer. It is often used and then made worse by tilting the camera or shooting at an angle so that the horizontal lines are sloping and converging.

Red brick is also an undesirable colour for portraits outdoors. Since red is an 'advancing' colour it reduces the impression of depth and the subject will not stand out well. It also clashes with flesh colour, especially a sun-tanned face, so it is wise to avoid brickwork altogether if your primary object is to make a portrait and not just to show a figure for scale or decoration in a portrait of an important building. In such a case the subject is better shown looking at the building and therefore away from the camera.

Another very distracting background is a loose hedge or bush. The colour is probably a good choice, but highlights caused by the sky or the sun showing through tiny gaps produce a very speckly effect. Choose a hedge thick enough to exclude all light from behind it.

Confusion of interest is another error made by many people on holiday. It is always a temptation to pose the family or friends in front of Blackpool Tower or the Doges' Palace, but such backgrounds are so interesting in themselves that a viewer may well feel irritated that figures are blocking part of the view. He may be left wondering what he is supposed to look at, especially if the figure or figures are looking towards the camera. Pictures like this have some documentary value for the family album but they are not portraits.

Yet another common error in outdoor portraits which occurs through neglecting to study the background in the viewfinder is that of having a tree, a telegraph pole or something similar

growing out of the top of the subject's head. Likewise, an horizon line can sometimes be seen going in one ear and out of the other, or the Great Pyramid can appear to be sitting on the subject's head like a coolie's hat.

It is obvious from all this that a golden rule for outdoor portraiture is to keep the background as simple as possible so that it does not look fussy or distract the viewer from the subject. A plain white or light-coloured wall will often serve and a thick hedge is usually very good if kept out of focus. Failing these, the sky can be used if there is some colour in it. A blue sky looks good in a colour portrait and, with the aid of filters (see Chapter 5), can provide plenty of tone for a black-and-white portrait. Remember, however, that no amount of filtering will put tone into an overcast sky that is devoid of blue, and nothing is more boring than a plain white sky in a colour or a monochrome portrait.

If none of these options is available, the only recourse is to use as large an aperture as possible so that whatever background is employed as a compromise it will be well out of focus. As a matter of fact, any background, however appropriate, should be kept at least a little out of focus. It is therefore a good idea to work with large apertures and to match the shutter speed to the one chosen rather than *vice-versa*. Large apertures will mean fast speeds, and this is an advantage because it will reduce any danger of movement as well as facilitate the use of the slower speed films.

As a general rule, it is wise to keep backgrounds fairly even all over. This means avoiding part sky and part landscape—have all of one or all of the other. By shooting downwards it is sometimes possible to get an all-over background of green grass or, by shooting upwards, an all-over background of sky. Few things are worse than the portrait taken in the back garden that has a bit of sky at the top, the line of a fence coinciding with the shoulders, and the greenhouse, some white flowers and the garden path thrown in for good measure!

Outdoor lighting

The direction of the light in outdoor portraits is just as important as it is in the studio because on it depends the modelling and form of the subject. It must be remembered that even on the most overcast day, when the sun is completely obscured and no shadows are visible, the light is still coming from the direction of the sun, so it will establish the shape of the head and the degree of texture rendering.

Film manufacturers used to say that you should always shoot with the sun behind you. But, as has been mentioned before, this was a counsel of safety and it is, in fact, the worst possible lighting. It produces very flat results because the shadows cast by various parts of the subject are unseen or at a minimum. In addition, one plane merges into the one behind and so on, thus destroying any illusion of depth.

The lighting should always be to one side of the camera to be sure of good modelling, and the ideal for outdoor portraiture is somewhere between 30° and 60°, depending on the subject. With children and women the wide angle is probably better, but for men, especially character subjects where it is desirable to emphasise ruggedness and wrinkles, 50° to 60° is better.

Lighting contrast

On a very bright and sunny day the contrast between highlight and shadow may well be greater than any film can accommodate. In other words, if exposure is short enough to retain detail and tone in the highlights, the shadows will be underexposed and devoid of detail. Alternatively, if exposure is calculated to give enough exposure to the shadows, the highlights will be overexposed and 'burnt out'.

A compromise between the two is also unsatisfactory. Both highlights and shadows will be compressed and the result will be flat. It is therefore necessary either to reduce the contrast by artificial means, to shoot in the shade or to wait for an overcast day.

When the sun is obscured by cloud the light is usually within the range of most films. Likewise, when the sun is very weak, because of early morning or evening haze, it is also manageable, although exposure must be accurately measured since there will not be much latitude.

On a bright sunny day the simplest solution is to pose your subject in the shade, because the contrast there is likely to be well within the capacity of any film—even colour, which has far less contrast capacity than the average monochrome film.

However, this is not always satisfactory. In colour the results tend to be rather cold even when a UV filter is used, although the filter will warm it a little. Also, you may want a sunny atmosphere because it is more in keeping with the mood or type of subject, so artificial means of reducing contrast by illuminating the shadows without losing the cast shadow forms is a better answer.

The simplest of these is a natural reflector. If the subject can be posed near a white wall in such a position that the light from the sun is reflected back into the shadows, a very satisfactory result can be obtained. The degree of contrast can be controlled within a wide range by varying the distance between subject and reflector. When shooting on the beach it is possible to pose a person so that the sand acts as a reflector, and, of course, snow can perform the same function in winter. Some enthusiasts always buy white cars so that they can be driven into a suitable position to act as a reflector. Many a good glamour shot has been taken with the model leaning over the bonnet or roof of a white car.

If a willing helper is available, a newspaper can be held in a position that will reflect the sunlight and it is capable of fine adjustment because the exact effect can be seen. It is always a surprise to anyone trying this for the first time to see how much light a reflector can return, but it is wise to remember that the eye is much more accommodating than film. The iris of the human eye adjusts very quickly when looking from highlight to shadow, so the subject does not appear to be nearly as contrasty

as the final photograph will be. Viewing a subject through half-closed eyes helps to gain a better impression of true contrast, and some people even view the subject through deep blue glass for the same reason.

When using colour film the reflector must be white otherwise some of its colour will be reflected into the shadows, although some people think that the warmth of the reflection from sand is an advantage rather than a drawback. Lastly, it is very important to remember that the reflector is solely for reducing contrast by illuminating the shadows, so the exposure must be measured for the highlights. This means taking the meter right up to the subject highlights or using the highlight method of reading. (See Chapter 6, incident light reading.)

Synchro-sunlight

Another method of reducing contrast is to use flash for putting some light into the shadows. This technique is growing in popularity because nearly all modern cameras are synchronised for flash and electronic flashguns have made the cost per exposure almost negligible. The only drawback is that it is impossible to use fast shutter speeds with focal-plane shutters. Apart from this, it is a most satisfactory way of controlling contrast on very bright days and, with a little practice, is easy to use. (See Chapter 6 for full details of exposure calculation.)

Posing the subject

Enthusiastic photographers often have a dusty patch on the left knee of their trousers because they know that by kneeling to take a picture of a pretty girl they will be making her legs look longer; also, men will look taller and more dignified. This is not the only reason for the low viewpoint. It is part of a desire to be different or more original, so shooting from above or below normal eye-level is always a good thing. It also facilitates even tone backgrounds, as mentioned earlier in this chapter.

For more dramatic effects the subject can be posed on a wall,

breakwater or ladder and this will make a good contrast to the more conventional portraits in the family album. A high viewpoint is perhaps not so desirable, except for subjects with prominent chins. Many pictures of pets and children have been spoilt because the photographer has looked down on them from a standing position. It is much better to lie on the ground, level with the subjects. By using zone-focusing (see Chapter 8) and putting a white sheet or blanket on the ground to throw light into the shadows, it is possible to get lively action pictures of young children.

Babies that are too young to sit up can be laid on a blanket on the grass and shot from above, but stand between the baby and the direction of the light otherwise there will be excessive reflection of the sky in the eyes, making them look unnaturally light.

For older children and for adults, action pictures are far more interesting and it is always advisable to give a subject something to do if he or she is not already occupied. The opportunities are too manifold to list and must depend on the photographer's imagination. But, just to illustrate the point, try getting a child to leap a breakwater while you lie on the sand and shoot up at him. A much more exciting picture will result than that obtained by posing him unwillingly against the breakwater with a command to stand still.

Another way of getting a little touch of the unusual is to take portraits at or near sunset when the light is warm and the shadows are low and long. With the subject looking into the sun or silhouetted against it there is a touch of drama and atmosphere that is lacking in the normal middle-of-the-day picture.

It is always advisable to avoid putting the subject in the centre of the picture. Try to keep him a bit to the left or right of centre and a little above or below, otherwise the effect may be too symmetrical. In a close-up portrait, when the face is almost filling the picture space, this advice applies to the eyes.

In the case of action portraits a 'directional' tendency sometimes appears. For example, if a figure is walking across the

picture to the left, the viewer's eye will tend to look in that direction. Likewise, in a close-up portrait the viewer's eyes will follow the direction of the subject's gaze, presumably as a result of a natural curiosity to see what he or she is looking at. If the subject is too near the edge of the picture, the viewer's eye may be led right out of it, so there should always be plenty of background between the subject and the edge or some dark tone to 'arrest' the eye.

It is a sound rule to have people 'looking into' a picture rather than 'looking out'. This will make for a better design and a feeling of unity in the composition. Experiment with poses. Never have a subject 'square-on' and standing to attention. Women should always relax so that the body forms an 'S' curve, and there is nothing wrong with posing them with their backs to the camera but looking over the shoulder—much more interesting! Men are usually associated with action, so a pose that puts the body on a diagonal instead of a vertical is more dynamic. Diagonals, like a runner at speed, always produce a feeling of movement and vitality.

Lastly, consider perspective. Close-up portraits taken with a standard lens at a few feet distance will show very ugly perspective, as well as an unnaturally large nose unless it is in profile. Far better to fire from 6 or 8 feet away and enlarge the result. For colour transparencies, of course, this is not so easy, and a long-focus lens is desirable, failing which the picture must be planned and composed as a three-quarter or full-length portrait.

The multiple portrait

So far we have only considered the single portrait, but often a group picture is required. The golden rule for this is never pose the subjects like a row of soldiers. Break the line by getting some to stand, some to sit and some to kneel on the ground, and also place them on different planes. Never leave gaps between the figures but arrange them to overlap so that they form a unit.

Have them carry on conversations so that they are looking at one another instead of staring into the lens and this will form an imaginary link between all the components of the group.

Even with small groups of two or three it is important to have them looking at one another and even leaning towards, or overlapping, each other. For example, a portrait of a bride and groom outside the church will be better if he stands just behind and looks down into the bride's upturned face. Thousands of full-length wedding pictures appear in the press showing bride and groom standing stiffly side by side. Much better to have them walking away from the camera, holding hands and looking back over their shoulders.

When there are more than two people in a group it is always pleasing to arrange them in a pyramid, if it is not too symmetrical. The line formed by the outlines of heads and shoulders should always be observed because it plays an important part in any group composition.

Further reading on outdoor portraiture

The Photographic Portrait, O. R. Croy, Focal Press.
Take Colour, Leonard Gaunt, Focal Press.
Amateur Photographer's Handbook, Aaron Sussman, Thos. Y. Crowell Co.

10 Holiday and Travel Photography

Many people use their camera only at holiday times and then are disappointed because something goes wrong. Like a car that has been laid up for the winter, a camera needs some checking over after a long period of disuse.

The shutter lubrication may have got gummy, so it should be operated at every speed at least ten times. The iris diaphragm should also be opened and closed a number of times. These operations can be done without a film in the camera, but it is also advisable to expose and develop a film before going away. This is especially wise with automatic cameras because it tests the exposure meter system as well.

Make sure that the inside is completely free of dust, sand or scraps of film, and if a battery is incorporated in the camera it should be replaced. Miniature batteries are difficult to obtain in out-of-the-way places. A few thin plastic or polythene bags are useful to protect camera and film from dust and spray when not in use, but take them out at night in hot climates otherwise condensation may cause damage.

Make a note in your diary of camera and lens numbers in case of theft, and ensure that your insurance covers the camera because some policies are limited to travel in the United Kingdom. Take receipts or insurance policies to prove to the Customs, if necessary, that the camera was purchased in Great Britain and duty paid.

In some countries the electric supply is still only 100 or 110 volts, so the charger for an electric flashgun should have a voltage adjustment. Otherwise it might be safer to use flash-bulbs or flashcubes. It is better to buy these before going abroad since they are cheaper here than in most foreign countries. Also, film is considerably cheaper in Great Britain than

almost anywhere in the world, so take plenty with you. No country will object to a reasonable supply being imported, whatever the regulations may say.

Keep colour films in their metal containers and post them to the processors as soon as they are exposed. This will avoid any damage through humidity during storage in hot climates. Likewise, black-and-white films should be kept in metal cassettes, but they are unlikely to suffer except under extreme conditions and so can be kept until returning home. As a precaution, a little packet of silica gel can be kept in the camera bag or the hotel drawer.

A problem that exercises the minds of some enthusiasts is whether to cover the holiday in colour or black-and-white, or both. If it is decided to double everything, two cameras are necessary, because with one camera alone it will almost certainly have colour in it when black-and-white is wanted and *vice-versa*.

The ideal arrangement is to have two identical cameras, with one member of the family in charge of one camera while another member carries and uses the other. When this can be done it is an advantage to use monochrome and colour films of the same ASA speed. This will mean that only one person need carry an exposure meter and the assistant will set focus, aperture and shutter speeds to match.

Planning coverage

Many slide shows or holiday albums are boring because they show an unbalanced coverage, with too much concentration on one or two events or people. It is no bad thing, and can be very rewarding, to plan the coverage of a holiday or a tour in much the same way as a film director would script a documentary. This will ensure that nothing important is missed out, although it will probably mean some ruthless rejection or weeding out afterwards.

First, list the items that will give coverage and continuity. It could read something like this: departure, arrival, venue, local

architecture, the beach, family on the beach, water skiing, surrounding landscapes, excursions, flowers, animals, local characters, sunsets, cabarets, departure. It helps to study travel brochures in advance because they show the local subjects of interest and often give details of special events, such as carnivals, beauty contests, etc., that are worth photographing.

A good slide show, like a film, should have variety by including both long shots and close-ups. The general character of a scene or a building can be shown in a long shot, and it will have added interest if it is followed by a close-up of a figure in the scene or of an architectural detail. Close-ups of street nameplates, signposts, inn signs and station boards make interesting titles. In a country that has characteristic music it is also a good idea to buy a record or tape that can be used as appropriate background music for a slide show.

Remember that one landscape looks very like another unless something typical of the country is included, such as a castle in Spain, a chalet in Switzerland or a mosque in Morocco. Likewise, a seascape should have something of local interest, like a junk in Hongkong, a Thames barge off Southend or a sardine boat in Portugal.

Failing these, it is usually possible to include people—but they should be natives and not other tourists or members of the family. In most countries people do not object to being photographed, so there is no need to be shy about taking shots of people walking about or doing their normal work. In the Arab countries, where there is still some objection, it is usually found that a minority will pose in return for a small payment and tour guides can always find such people.

Some people ask 'why bother with a camera when perfectly good postcards and transparencies can be bought almost anywhere? They have been taken under ideal conditions with large format cameras.' The answer is that it is their very perfection that makes them dull. They are usually pin-sharp on every plane and taken in normal middle-of-the-day sunlight so that they are often lacking in mood or atmosphere. Nevertheless, they are

worth studying because they show subjects that are important as well as landmarks that you might otherwise miss. It is fun to see how you can improve on them by changing the viewpoint, using differential focus and shooting under different lighting conditions.

Try to get plenty of local people into the shots and don't pose them like so many of the figures seen in postcards and transparencies. If you must include your friends or family, have them looking at the buildings or into the distance—anything but 'now look at the camera' expressions.

Pictures at night can convey a lot of atmosphere and fast modern films make many things feasible. Floodlighting, fireworks and market stalls lit by flares are always interesting, but support the camera where possible in order to give a long exposure. In many countries flash is not discouraged, as it is in the nightclubs and theatres of Great Britain, so carry a camera everywhere and save that sad remark so often heard 'I wish I'd brought my camera!'

Improving the quality

Everybody wants to take better pictures without becoming too involved with technicalities, and everybody can produce a set of holiday pictures that will stand out from those of their friends if a few golden rules are put into practice. They are:

(1) Shoot as many pictures as possible early in the day or late in the afternoon when the light is warm and the shadows are long and interesting.

(2) Don't wait for the sun to come out. Shoot when it is misty or when it is raining, and especially when there are dramatic cloud formations. Don't neglect reflection pictures in puddles, lakes and rivers.

(3) Take plenty of pictures facing the sun so that figures and other subjects are attractively outlined with light. These are probably the most striking and artistic pictures of all.

(4) Take pictures at night of anything that is naturally illuminated outdoors.

(5) Don't be put off by lack of light for indoor events—take a flashgun on holiday.

(6) Try to find unusual angles—low viewpoints, high viewpoints and ultra close-ups.

(7) Use filters where appropriate for black-and-white work in order to falsify tones, e.g. darker skies, for dramatic effect.

(8) Keep the composition simple in order to achieve impact. This means getting close to a foreground object, perhaps a figure, so that it dominates the picture and everything else is subordinate to it. A hundred elements all of equal interest only produce confusion. In colour it is desirable to have the dominant foreground object in a warm colour: a yellow dress is better than a blue one and will give a stronger impression of depth. Check also for opportunities to 'frame' the scene by shooting through an arch, a window or under a tree.

All these points are dealt with in greater detail in other chapters, especially Chapter 7 on landscapes, Chapter 9 on outdoor portraiture and Chapter 11 on night photography.

Exposure problems

It is all too easy to overexpose when taking a holiday abroad, especially in a tropical country, by the sea or up in the mountains. On the beach, for instance, the reflection from sand is often enough to give a false reading, even when the meter is pointed downwards to avoid taking in too much sky. There is a lot of ultra-violet in the light and this affects the film, so it is wise to close the diaphragm by one stop. The only exception would be for shooting a figure against the light, when it would generally be advisable to open up about half a stop.

An open seascape has a lot of blue in it and this is rich in ultra-violet, so give no more than half the indicated exposure, i.e. close down one stop or use the next faster shutter speed.

This also applies to mountain scenes. In both these cases an UV filter should be used to absorb some of the ultra-violet rays, and it will also help to warm up a colour shot.

Further reading

Your Holiday in Colour, Kodak booklet.
Successful Colour Photography, C. Leslie Thomson, Focal Press.
Camera Afloat, H. S. Newcombe, Focal Press.
Camera in the Tropics, G. C. Dodwell, Focal Press.
Camera on Safari, John Sherman, Focal Press.

11 Night Photography

Photographs taken after dark have a special fascination and they are easy to take in either monochrome or colour, even with simple budget cameras.

There are two ways of taking night pictures: by time exposure or by instantaneous exposure. The former can be taken with any camera, but a tripod or some other firm support will be required and moving objects cannot be included. Instantaneous pictures usually require a large-aperture lens and the use of fast films, but the camera can be hand-held and quite a lot of action can be captured if the light level is reasonably high.

Time exposures

A firm tripod is ideal for all time-exposure work, but it is often inconvenient to carry a really rigid model, which is necessarily heavy. Lightweight tripods are useless in the slightest breeze, and even the shutter being released can cause them to vibrate. It is better, where weight is a consideration, to use a pocket camera clamp or to employ one of the miniature table-top tripods that can be set up on a wall, a pillarbox or any handy but firm support at the right height. The best of these miniature tripods fold up to make a good handle grip or stock that helps to hold the camera steady when used in the hand.

Much will depend on the weight of the camera, but a good test is to open the back with the lens focused on a light in the distance. Release the shutter and hold it open for 10 or 20 seconds and the slightest movement of the light will become obvious to the eye.

A cable release is necessary for time exposures, otherwise the camera might be left vibrating after the shutter release has been

pressed. If the camera has both a T (Time) and B (Bulb) setting, the T setting should be used. This opens the shutter, which will stay open until the release is pressed again. Many cameras have only a B setting, and for these it is useful to purchase a cable release with a locking device so that it can be pressed and locked until the exposure is completed. Otherwise the release must be held throughout the exposure, which inevitably increases the risk of jarring the camera.

Under low lighting conditions and when a small aperture is employed to get a good depth of field, it may be necessary to give exposures running into many seconds or even minutes. This means that moving lights such as car headlamps can cause streaks or lines of highlight. Sometimes these can be attractive and add a feeling of movement to a street scene, but if it is desired to eliminate them it is easy enough to hold a hat or a book in front of the lens until each car is out of the picture.

When exposures run into a number of seconds, people walking across the picture are no problem because they will not be recorded unless they happen to be in a bright light area, such as the pavement in front of a lighted shop window or under a cinema canopy. In these cases they will form 'ghost' images if they are present only for part of the exposure, so it is better to wait until they have gone.

There is very much more latitude in exposure at night than in daylight and this is a real advantage for colour work, which normally requires very accurate exposure assessment. The results can be presentable over a wide range of exposures, although the colours may vary. For example, if an exposure of 1/15 second is given to a neon sign, the result may show little more than the actual tubes, but increasing the exposure to 1/2 second could well show some of the brickwork behind. Increase it still more and probably the detail in the windows, or even a glow in the sky, will appear. In all these exposures the sign will still look the same although there may be more halation around the tubes with the longer exposures, but all will be acceptable as pictures.

Most people prefer to use daylight-type colour film for night photography. The results are warmer than they would be with artificial-light film, but this, if anything is an advantage. With all colour films the exposure should be kept as short as possible because of a factor called reciprocity failure. Certain films change their characteristics when extremely long or extremely short exposures are given. This may affect the colour rendering and exposure increase is often required. This is not likely to affect most amateur work, but the film instruction leaflet should be consulted.

Unfortunately, no exposure meter is powerful enough to take readings under most night conditions, but the table below should give some guidance. It would be as well to 'bracket' exposures by taking further shots at one half and double those shown. The table is based on 50 ASA film, and exposures should

Subject	f/4	f/5·6	f/8	f/11
Big fire: well-lit outdoor stage	1/30 s	1/15 s	1/8 s	1/4 s
Boxing ring under spotlights	1/125 s	1/60 s	1/30 s	1/15 s
Well-lit shop windows: tube train interiors	1/15 s	1/8 s	1/4 s	1/2 s
Fireworks and bonfire	1/8 s	1/4 s	1/2 s	1 s
Portraits by shop-window lighting	1/4 s	1/2 s	1 s	2 s
Well-lit street scenes: Piccadilly, Times Square, etc.	1/2 s	1 s	2 s	4 s
Floodlit buildings and monuments	1–2 s	2–4 s	4–8 s	8–16 s
Floodlit buildings at a distance	4–8 s	8–16 s	16–32 s	32 s–1 min
Main railway stations	1 s	2 s	4–8 s	8–16 s
Distant scene with scattered lights	20 s	40 s	80 s	1½–3 min
Full-moon scene with snow	30 s	1 min	2 min	4 min
Full-moon landscape without snow	2 min	4 min	8 min	16 min
Stars in their courses				3 h

All the above times are for 50 ASA film

be doubled for 25 ASA and halved for 100 ASA and so on (see Chapter 6 on Exposure).

It is advisable for all night work, especially with long exposures, to use a lens hood to prevent stray light causing flare on the lens surface.

Aesthetic considerations

The beauty of a night picture is in its atmosphere and it is important not to overexpose or underprint so much that the result looks more like daylight. On the other hand, a lot of stygian black is undesirable, especially in colour transparencies, because it usually comes out as an unpleasant greenish or brown black.

As far as possible, the subject should be made to fill the picture space and too much sky should be avoided. If the picture is taken immediately after sunset when there is still a little afterglow in the sky, the result will be much more attractive, especially in pictures of floodlit buildings which may, under these conditions, also have a little detail in the shadows not reached by the floods. Sky tone is particularly important in pictures of buildings not floodlit but having a number of windows illuminated. Without some tone in the sky to outline the structure, the picture is liable to be merely a pattern of white dots.

It is also an advantage to take night photographs during or after rain. The reflections of the lights in wet pavements and roofs produce a romantic atmosphere and also help to avoid having areas lacking in detail or colour. Very often a picture may be required of a floodlit building on the other side of a river or of a ship in the docks. The water in front will show very attractive reflections if it is not too choppy and, indeed, many fine pictures have been taken solely of the reflections.

When making long time exposures it is necessary to avoid including the moon or any bright stars because they move quite a distance in the space of a minute and the moon will look

elongated while the stars will appear as curved white streaks. On the other hand, amusing pattern pictures can be taken by pointing the camera at the sky and leaving it open for several hours. Likewise, some excellent lightning pictures have been obtained by placing a camera on a tripod at the window and pointed in the direction of the storm. If the shutter is left open for the duration sheet lightning will illuminate the landscape and the clouds, while forked lightning provides interesting patterns for contrast. There is obviously an element of luck in this but the results can be dramatic.

While the inclusion of the moon or other moving light source is something to treat with caution there is nothing against street-lamps or other point sources being in the picture, provided that they are not too near the camera. The halation they cause is part of the atmosphere, and sometimes the iris diaphragm will cause them to create star patterns which are also attractive.

The long time exposures that are required at night provide opportunity for multiple exposures. At a firework display, for example, the shutter can be left open long enough to allow very many fireworks to record themselves on the film, thus creating a picture full of light and colour that conveys the mood far better than a single rocket could do. Another fruitful source is the amusement fair, where such things as carousels and ferris wheels can produce unpredictable but pleasing results.

Using flash at night

With some subjects time exposures can be augmented with flash. For example, when a floodlit building or an illuminated street scene is being photographed, the exposure may still be too short to record foreground objects that are not themselves illuminated.

There are occasions when a silhouette of these objects or figures is desirable, but often a little detail is an advantage and flash is the answer. Obviously it must not be strong enough to light the foreground at the expense of the background or it

would look very unnatural. A satisfactory compromise is reached in most cases by giving full exposure for the background and about one quarter for the flash. In other words, after the flash exposure is calculated by the guide number in the normal way (see Chapter 6) the aperture is closed by two stops or, if this is not convenient, the distance of the flash from the subject is doubled.

Suitable subjects for this technique are figures in front of lighted shop windows or floodlit buildings, statues in the foreground of street scenes, trees in front of houses with illuminated windows and figures in front of a bonfire. If the figures are very close to the available lighting, as they may well be in the case of the bonfire, it is most important not to overdo the flash exposure and 'kill' the fire. If the normal exposure is very long the figures must not be allowed to move very much otherwise ghost images will result, but this, of course, is no problem with statues and trees.

Instantaneous night photography

Fast films and wide-aperture lenses have made a certain amount of hand-held night photography possible. High-speed black-and-white films like Agfa Ultra, Ilford HP4 and Kodak Tri-X permit exposures of the order of 1/125 second at f/2·8 on many subjects like theatre entrances, well-lit buildings, flare-lit market stalls and big fires. Colour films, unfortunately, are not so fast, but with HS Ektachrome (164 ASA) some brightly lit subjects are possible, especially for the photographer who can hold a camera steady at 1/30 or 1/60 second. Some enthusiasts give this film a much higher speed rating and then force development, but this inevitably means some loss of colour quality.

It is therefore necessary to confine instantaneous photography to brightly lit subjects such as shop windows, the area under cinema entrance canopies, electric signs or close-ups of objects under powerful spotlights. When such pictures come off they are very rewarding because the distant scene is dark and the

romantic mood of night is well portrayed. Nevertheless, it is better whenever possible to take the pictures at twilight so that there is at least a suspicion of tone or colour in the distance or in the sky.

When houses or office buildings are to be included, make sure that some of the windows are illuminated or a door is opened to reveal interior lighting. Otherwise the result could just as easily be an underexposed daylight shot or one taken by infra-red—the true night atmosphere will be lost.

If people are included, get them as close as possible to the illumination. For instance, if people are being photographed arriving at a function, wait until they are almost at the doorway and receiving the full force of light coming from it. Under canopies, shoot before they have walked so far towards the camera that most of the light is immediately above them. If they are on the far side the light will be falling on the front of them.

Apart from the fact that night photography has a greater degree of latitude in exposure than exists for daylight photography, it is also a fact that a greater degree of movement is acceptable as long as something in the picture is sharp. Add to this the great impact of a good night photograph because of its special emotional appeal and the conclusion should be obvious—always carry a camera by night as well as by day. Some exposures may not be successful, but some are almost bound to be if the advice given in this chapter is followed and they will more than compensate for a few dull frames.

12 Indoor Lighting

Photographs, especially portraits, can be taken indoors by available daylight from a window or by the normal room lighting —ceiling lights, standard lamps, etc. However, neither method is easy and one stands a better chance of successful results by the use of overrun bulbs, called photofloods, or of flash.

The main disadvantage of daylight from a window is that the contrast will usually be excessive and some fill-in light from a reflector, flash or lamp will be required. In addition, of course, photography is confined to the hours of daylight.

The chief disadvantage of using the existing house lighting is the low level of intensity, which in most cases will demand longer exposures than are practicable for live portraiture. In addition, the colour temperature is too low for colour films, even of the artificial-light type, and the results will be far too warm unless correction filters are used.

Photoflood lighting

This is an easy, economical and satisfactory form of lighting for the home photographer. It employs bulbs that plug into any lamp socket and, in fact, look like ordinary domestic bulbs, but they are 'overrun' and give a very bright light for a limited life. The popular size, known as a No. 1 photoflood, gives a light equivalent of about 275 W and is available with a bayonet or ES cap. There is a larger bulb, called a No. 2 photoflood, that gives a light output of 500 W and comes only with an ES cap.

The No. 1 is quite adequate for the average user. It will burn for about two to three hours but will last ten hours or more if two of them are used in conjunction with a series/parallel switch or a distribution board. They can then be used at half power for

focusing and switched to full power only for the actual exposure.

Photoflood bulbs can be used in ordinary domestic fittings, like chandeliers or standard lamps, but this is not recommended except perhaps for party shots, where a general light of some strength is required. For portraits this does not provide enough flexibility or control over shadows and it is also inefficient because, without properly designed reflectors, much of the light is wasted.

Incidentally, it can also be dangerous to use domestic fittings because photoflood bulbs naturally get very hot and paper or fabric shades could catch fire if in close proximity. In every other respect the bulbs are quite safe and a number can be used on an ordinary domestic circuit.

The photographer who plans to do much indoor work by photoflood lighting should invest in special fittings which are economical and easily portable. These are like collapsible violin music stands but fitted with spun metal reflectors that can be angled in any direction. They can be raised or lowered from about $2\frac{1}{2}$ to 6 feet and are very light in weight.

The reflectors, which are interchangeable, are available in three forms. One is in the shape of a fairly deep bowl, often ribbed and chromed inside, and this gives a fairly hard and concentrated beam. With some makes of stand it is possible to move the bulb backwards and forwards in the reflector in order to vary the width and concentration of the beam. This is the nearest thing to the professional's spotlight and is useful as a main modelling light.

The second type is somewhat similar, but the reflector is shallower and probably has a matt finish inside. This is an all-purpose lamp and is very useful for softer modelling effects or for background lighting. The third type of reflector consists of a very shallow bowl painted matt white inside and with a baffle placed in front of the bulb so that no direct rays from it will fall on the subject. This gives the softest possible lighting and is almost shadowless, so it is used as a fill-in light to reduce contrast and to put some light into the shadows made by the main light.

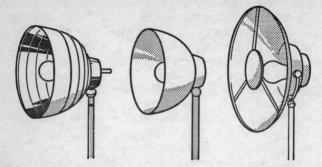

Fig. 19 Three types of reflectors for photoflood bulbs. The left-hand one is ribbed and chromium-plated internally to give a hard directional light. It can often be focused by moving the bulb backwards and forwards. The centre model is a shallower bowl, usually in spun aluminium, which gives a broader and softer beam. The right-hand drawing shows a very shallow bowl, painted matt white, and it has a mask in front of the bulb, so the lighting is very soft and almost shadowless. This one is ideal for a fill-in light. All models should be adjustable in any direction.

These reflectors are also available fitted with strong spring clips so that they can be clipped to a door, a chairback or a mantelpiece, thus avoiding the use of stands. Naturally they restrict one's freedom of placement to some extent, but one or two of these could be useful for the beginner to experiment with before investing in a number of complete stands.

It should also be mentioned that there is a certain type of photoflood bulb that is mushroom-shaped and has a built-in mirror reflector. This is useful in emergencies where proper reflectors are not available, but the type and width of the beam is fixed and so a large degree of flexibility is lost. They are also much more expensive but unlikely to give longer life.

With three stands and three different reflectors plus a series/parallel distribution board, one is equipped to take good photographs anywhere. Their use is described in the next chapter.

Type A (artificial-light) colour films are balanced for the colour temperature of photoflood lighting, which burns at about 3400 K, so no filters are needed. Daylight-type films require a Wratten 80B filter or its equivalent.

Flashlighting

Flash has some advantages over photoflood lighting. It is more compact and portable, and does not involve trailing wires if slave units are used. Also it is cool and does not create a studio atmosphere to make a timid sitter self-conscious. On the other hand, it has one big disadvantage in that one cannot see the effect of the lighting before making an exposure, so considerable experience is required in the placing of the lamps. True, some people fit tungsten 'modelling' lamps into their flash fittings, but this defeats the main advantage of flash and is only employed in the big units used by professionals.

There are two types of flash:

(1) Flashbulbs or flashcubes
(2) Electronic flash

Flashbulbs and flashcubes are sealed glass envelopes containing an inflammable wire that burns with a very intense light when ignited by an electric current. The duration of the flash is extremely short—usually about 1/600 second—and the bulb cannot be re-used.

Electronic flash also gives a brilliant light of very short duration and it can be synchronised with nearly all camera shutters. The only difference is that it can be fired over and over again—up to sixty or more flashes from one charge—and the life of the tube is almost indefinite. The pros and cons of bulbs versus electronic were fully discussed in Chapter 2.

When used on the camera, bulb or electronic flash gives a very ugly effect. Faces, or whatever is the main subject, lose their form and shape, while hard, ugly shadows are cast on the background. This can be avoided by using the flash well away from

the camera and connecting it to the camera synchronising socket via an extension lead. This inevitably means that some form of fill-in light will be required, otherwise the contrast will be much greater than any film can accommodate.

A reflector could be made to serve, but positioning it is very difficult because the effect cannot be seen until a print is made and slight variations in the angle and distance can make or mar the result. It is easier to use another flashgun for fill-in, and this can be placed on or near the camera because it must not cast shadows or conflict with the main light. It must also be weaker, so it should be farther away or have its power reduced by diffusing it with one or more layers of handkerchief or other white, semi-translucent material. People who use a large and powerful gun for the main light sometimes use a smaller gun for the fill-in light.

Naturally both guns must be synchronised and they can both be connected to the camera socket with a little two-way adapter; this, however, only works when both guns are of the same polarity. A more satisfactory method is to employ a 'slave' unit attached to one of the guns. It will cause the gun to fire as soon as the sensor cell receives light from the other gun. This method involves a little more capital outlay, but it is reliable and saves having trailing wires to fall over.

If a third flash is required for the background it can also be connected to the camera via an adapter if the polarity of all three guns is similar. Failing this, another slave gun can be made to fire the third flash.

Bounced flash

Much softer, and generally more pleasing, effects can be obtained by 'bouncing' the flash off a suitable reflector. If the gun is directed at a ceiling or wall at an angle that causes most of the light to be reflected onto the subject, the degree of contrast will be much lower. In a small domestic room with light walls there may even be sufficient general reflection all round to render a second light for fill-in unnecessary.

In colour photography it is important to use only white surfaces as reflectors, otherwise colour will be reflected onto the subject.

With this method of bouncing flash there is a substantial loss of light because of the extra distance it has to travel. It can be as much as four times, or two stops. A more efficient technique is to use white umbrellas as reflectors. They can be bought with universal heads that enable them to be fixed to a tripod and angled as desired. A shoe at the end of the stem takes the flashgun, which is directed towards the inside of the umbrella.

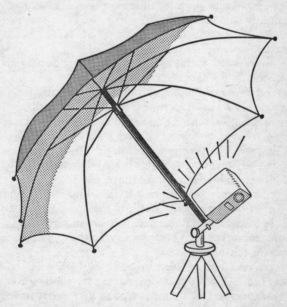

Fig. 20 White parasols or umbrellas fixed to the top of a tripod by an adjustable elbow or universal joint make ideal reflectors for bounced flash. They can be bought lined with opaque silver or gilt paint for maximum efficiency, or in white nylon for more diffused effects.

Since the distance of the gun to reflector remains constant it is easy to work out correct exposures for different distances between reflector and subject. Once this is done, accurate exposure can be achieved always and anywhere. The umbrella collects and reflects a very large percentage of the light and is not wasted by general scattering, as it is when a wall or ceiling is used. The difference between umbrella-bounced flash and direct flash can be as low as one stop.

Some people regard the effect given by bounced flash as too soft and they compromise by angling the gun so that most of the light is bounced but just a little from the edge is allowed to spill directly onto the subject.

Open flash

Flash is very useful for interior photographs that do not contain people or moving objects. The camera can be set up on a tripod and the shutter opened on 'Time'. Provided that the room is fairly dark and a small aperture is employed, the flash can then be fired repeatedly by hand in different directions. This is useful in a large room or the nave of a church which would be too deep for a single flash to penetrate. A flash fired from behind every pillar, and perhaps even two flashes behind the most distant ones, could give even illumination throughout.

Of course, the flash must never be fired towards the camera, and the gun and the user should be concealed behind the furniture or architectural features. It is also important to avoid windows, mirrors or shiny surfaces which may catch an image of the flash or cause flare.

It is impossible to calculate exposure with any precision for subjects like this, but the guide number can still be used as a rough indication for the flashes nearest to the camera. In a very large, dark interior the value of reflecting walls is lost and the exposure should be at least doubled.

From all that has been said in this chapter and in Chapter 2 it will be seen that both flash and photoflood lighting can be used

for most indoor subjects, and both are available in a convenient and portable form enabling the user to turn any room into a temporary studio. In the end the choice is a personal one, but there is much to be said for starting off with photoflood lighting, especially for portraiture. Being able to see the effect and to balance the main light with the fill-in to achieve a specific degree of contrast or a particular dramatic effect is useful experience and it will help the user to a quick appreciation of the principles of lighting.

Further reading on lighting

Lighting for Photography, W. Nurnberg, Focal Press.
Light on People, Paul Petzold, Focal Press.

13 Indoor Portraiture

Elaborate equipment and expensive cameras are not essential for indoor portraiture. Sophisticated apparatus provides scope for greater versatility, but good portraits can be taken in the home without it, provided that the limitations of the apparatus are understood.

A tripod or some means of supporting the camera is essential because the camera must be left in position while the lights are being deployed and the pose arranged. If close-ups are required a long-focus lens or a portrait attachment will be necessary. Taking a 35 mm camera closer to the sitter than about 6 feet will cause unpleasant perspective distortion, resulting in exaggerated noses and diminutive ears. At this distance the standard 50 mm lens will include about three quarters of the figure. When working in black-and-white the head and shoulders alone could be enlarged, but for colour transparencies selective enlargement is a costly and not very satisfactory process. A lens of 90 or 105 mm is a great asset. Two other accessories on the camera that are desirable, if not essential, are a lens hood to keep stray light off the lens and a cable release at least 12 inches long.

There are four methods of lighting the subject:

(1) Daylight from a window.
(2) Available indoor lighting. This can be ordinary electric lights or a combination of daylight and electric.
(3) Photoflood or tungsten lighting.
(4) Flash.

There are pros and cons for each method and only the user can decide which suits his purpose best.

Daylight lighting

Light from a window can be employed to produce very satisfactory portraits, but it is, of course, limited to the hours of daylight, which in winter, when most indoor portraits are taken, is limited in strength and duration. It is also very variable, so exposure readings must be taken constantly and exposure cannot be standardised, as it can be with artificial lighting.

Windows that face south should be avoided. Direct sun is too hard and it will probably make the sitter squint. The softer and more even light from a window facing north is ideal, and it is an advantage to mask off the lower part of the window so that the light reaches the sitter at an angle of 30° to 40°. This is the modelling light so much favoured by portrait painters like Rembrandt.

In order to have room to manoeuvre, the sitter should be at least 5 feet away from the window and placed well back so that most of the light falls on the front of him and not behind him. It will almost certainly be necessary to use a reflector or fill-in light to illuminate the shadow side of the subject unless an exceptionally dramatic and contrasty effect is required.

Any large area of white will serve as a reflector—a newspaper or a sheet, for instance. If a free-standing cine or slide screen is available, use that because it can easily be moved about until a position is found where it reflects the most light. For colour portraiture the reflector must be white otherwise colour will be cast on the subject and, of course, daylight-type colour film must be used.

As an alternative, artificial light or flash can be used as a fill-in. Artificial light could be used for black-and-white work, but in colour portraits this would be mixing lights of different temperatures and the result would be most unnatural. The difficulty with flash is that it is impossible to see the effect in advance and it is only with a great deal of experience that the correct exposure to obtain the desired degree of contrast can be gauged with certainty.

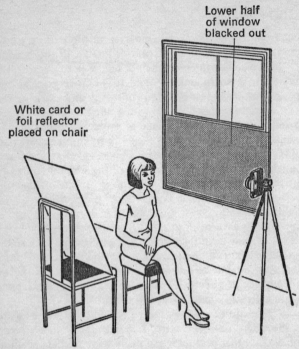

Lower half
of window
blacked out

White card or
foil reflector
placed on chair

Fig. 21 For indoor portraits, using daylight as the main light source, the window should be masked off so that the light falls on the sitter at an angle between 30° and 40°. A reflector or fill-in light will be required to illuminate the shadows and record some detail.

In any case, the flash must not be allowed to cast shadows or to conflict with the daylight, so it should be as near as possible to the camera/subject axis and should be bounced off a reflector. Umbrella flash is ideal for this, but if there is a wall behind the camera this can be used. Exposure must be based on the daylight, so a reading should be taken on that and the flash calculated to give the degree of contrast required.

For example, suppose the daylight reading indicates 1/50 at f/8 with 50 ASA film. If the guide number for the flash bulb or flashgun for this speed of film is 80, then full illumination would be obtained with the flash at $\frac{80}{8} = 10$ feet. However, the flash is reduced to about quarter strength (or two stops) when bounced, so at 10 feet the result would show a ratio of approximately 2:1, which is quite good for colour. On the other hand, if a greater contrast or more dramatic effect is required, as it might well be in monochrome work, the bulb or gun would have to be reduced in strength. In the average domestic situation it may not be practicable to extend the distance between flash and sitter, so layers of handkerchief (see Chapter 6) would be the answer. In any case, it is always a bad thing to have a flash placed behind the camera and operator because it is very easy to get in front of it and thus destroy its effect or cast a shadow over the subject.

The background can be a problem. If there is a plain wall in the right position to receive some of the daylight at the right strength, that is fine, but usually it will be necessary to light it separately unless a very dark tone is acceptable. This can also be done with flash and, in fact, it might even be possible to place the fill-in flash so that it performs both functions, but this can only be found by experiment.

Experiments made with a wig stand as a model and with careful notes made of daylight exposure and distances of flash or reflectors will provide data and experience that enable any effect to be thereafter repeated with confidence.

Available light

It is almost impossible to do serious, formal portraits in ordinary room lighting because of the fixed positions of most of the lights, and in many cases the level is so low that long exposures would be required, so the risk of movement is high. Nevertheless, there may be occasions when it is desired to 'snatch' a picture of a person at a party or function. If possible, get him or her to stand

or sit below a ceiling light but a little behind so that the light falls on the face and not just on the top of the head. If the ambient light is strong enough it may provide sufficient illumination for the shadows, but there is always a danger of dark shadows under the chin and in the eye sockets. This can usually be overcome by asking the subject to hold a book or newspaper as if about to read it because it will reflect some light upwards.

If a movable desk or standard lamp is available it can also be employed for the same purpose, especially if the subject is seated, but the principles of lighting explained later in this chapter must be observed and this is not always possible with such makeshift methods. It should also be noted here that fluorescent lighting is unsuitable for colour without the use of filters, and the mixture of lighting sources such as daylight, artificial lighting and fluorescent must be avoided completely. Thus if artificial-light-type film is used, curtains must be drawn over the windows to prevent any daylight entering and any fluorescent tubes must be switched off. Note also that Type A colour film is balanced for photoflood lighting and ordinary domestic bulbs will give a rather too warm effect, so a filter such as an 82A (blue) may be necessary.

Photoflood lighting

This is a far more satisfactory method of lighting for home portraiture than either daylight or available light because the operator has complete control over modelling and contrast. In addition, it can be easily set up and used at any time, anywhere.

Using the apparatus described in the last chapter, consideration can now be given to the basic principles of lighting for portraiture. The first, and by far the most important, is the use of the main light to 'draw' the subject. This light, which is sometimes called the modelling light or the key light, is in effect the equivalent of the sun in an outdoor portrait, so it must dominate the picture. In the final result it should not be obvious that any other light source has been used at all.

It is a salutary exercise to place a simple foam-plastic wig stand or hairdresser's dummy on a table or stand about 3 feet from the floor and walk round it with a photoflood lamp in a deepish bowl reflector and with all other room lights turned off. Start by holding the lamp at camera position and the face will look very flat indeed. Walk round slowly to the left or right, keeping the light on the same level as the subject. It will gradually take on more shape and roundness until, at 90° to the camera/subject axis, the face is split into two: half lit and half in darkness.

Then do the same thing but with the lamp held much higher so that it is shining down on the head at about 45°. From the front it will look a little theatrical and at 90° there will still be a rather divided effect. However, at 45° it will be seen that the head is showing the maximum modelling and shape.

Therefore it is wise to start lighting any full-face or near full-face subject with the main light only, and at an angle of about 45° in plan and 45° up. It may be necessary in some cases to lower it slightly, even down to about 30°, or to bring it round to the front a little to avoid heavy shadows in deep eye sockets or long shadows under big noses. Many photographers use the nose shadow as a guide for the height of the mainlight and always adjust the angle so that the shadow falls at an angle across the upper lip but ends just short of the lip itself.

Naturally when the pose requires the head to be turned a little away from full face the lighting set-up will need to be adapted accordingly. It is always preferable to have the main light on the side that the subject is facing, otherwise the back of the head may be better illuminated than the more important face.

The exercise suggested will also show how the angle of the light affects texture and therefore the final effect. At 45° and beyond it is creating shadows in every nook, cranny and furrow, so it is ideal for character rendering—in other words, for men and for old ladies where it is not desired to sentimentalise them. At the lesser angles the shadows are reduced, so the effect is more

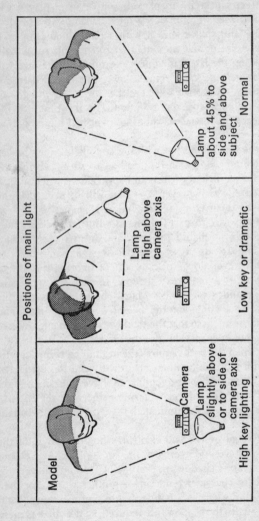

Positions of main light

Model

Camera

Lamp slightly above or to side of camera axis
High key lighting

Lamp high above camera axis
Low key or dramatic

Lamp about 45% to side and above subject
Normal

Fig. 22 The basic lighting positions described in the text. The second and third arrangements normally require a reflector or a fill-in light near the camera/subject axis.

flattering and therefore suitable for most female portraits, glamour pictures and children's portraits.

It should be emphasised here that the decision on the final contrast must be made at this point. It is no use placing the light at 45° and then trying to produce a high-key picture by adding a powerful fill-in or, conversely, putting the main light in front and then trying to get contrast by reducing the fill-in. Both results will look unnatural. The simple rule is to place the main light well up and well round for low-key, character and contrast pictures with plenty of texture, and to place it nearer the front, as well as lower, for gentler, softer or high-key portraits.

Incidentally, the positioning of the light can be done with it on half power if a series/parallel switch or circuit board is employed. It will not affect the final result and will save the sitter some discomfort, although with a little experience the correct position should be found in a second or two.

At this point the nature of the main light should also be considered. Many professionals use a spotlight that gives a concentrated beam that causes sharp-edged shadows, but for domestic purposes a deep bowl reflector is good enough and the shadows it casts are clear enough for average character portraits. In fact, it might be a little too hard for glamour subjects and a shallow bowl would be a useful addition to the outfit for high-key and low-contrast pictures.

Having established the correct angle to suit the subject and the degree of modelling required, the next consideration is the distance of the light from the sitter. The strength of the light falls off so rapidly with distance that it is dangerous to place the light too close, especially when it is at a high angle, otherwise the forehead will be much brighter than the chin. A bald-headed man will not thank you for this! Make it a rule to place the light as far away as is practicable in the space available and never less than 5 feet for a head-and-shoulder portrait. For a three-quarter or full-length picture the distance must obviously be increased accordingly. The more concentrated the type of reflector, the more likely it is to have a 'hot spot' in the centre.

When, and only when, the position for the main light has been satisfactorily settled, the secondary or fill-in light should be switched on. This light is solely for putting illumination into the shadows and is required because all films have a limited contrast range, far less than the human eye can accommodate. When the eye is transferred from highlight to shadow, the iris opens to compensate for the change, but film cannot do this. What looks reasonably well lit all over will come out far too contrasty in the negative. In other words, if the exposure is based on the highlights the shadows will be underexposed and lacking in detail, or if the exposure is long enough to record shadow detail the highlights will be overexposed, 'burnt out' and devoid of tone. In fact, the situation with a main light alone is similar to the bright sunlight discussed in Chapter 9.

It follows that the fill-in light must be, as near as possible, completely shadowless or it will conflict with the main light and cause unpleasant cross shadows. For this reason it should be kept as close to the camera/subject axis as possible and a very shallow, white-painted bowl reflector, as described in the last chapter, is ideal. Failing this, an ordinary photoflood in a bowl reflector could be bounced off a white wall or suitable flat surface.

The relative strength and distance of this light will determine the contrast of the final result. In colour photography, where the contrast range of the film is more limited than in monochrome, a ratio of about 2:1 suits the average subject. The colours themselves help to separate planes and provide modelling, whereas in black-and-white much of it is dependent on tone variation. In monochrome the contrast can be as much as 4:1 or 5:1 before it comes outside the limits that a print can show. A low-key picture where minimum detail is required in the shadows can even extend beyond this, but in general it is wise to keep the range for monochrome between 2:1 and 5:1 according to the effect required.

With the aid of an accurate exposure meter it is possible to measure both the highlight and the shadow, thus ensuring that

the contrast is not too great. This should be done from a similar tone or colour for each reading, and if in doubt use a light grey card. When the meter is on the camera it will only be taking an average reading and it will not indicate the degree of contrast. As with so many things, experience teaches a lot and after a

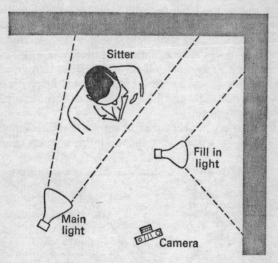

Fig. 23 When working in a confined space a corner may provide a possible background as well as a suitable reflecting surface for fill-in.

time the final effect can be judged without measuring. It helps to half close the eyes because this increases the apparent contrast and some professionals use a deep blue viewing glass for the same reason. Until enough experience has been gained several exposures should be made with the fill-in light placed at different distances and a note made of each.

When the main light and fill-in light have been satisfactorily positioned the background must be considered. It may be that

the tone is satisfactory as a result of the light falling on it from the main light and fill-in light. Because of its greater distance this will come out darker than it appears to the eye, so it should also be studied through half-closed eyes.

However, it may well be found that the main light is throwing a shadow of the sitter on the background. Under no circumstances should the main light be moved further round in an attempt to move the shadow out of the picture area—once properly positioned the main light should never be moved. The answer is to move the background further back, in which case it will come out darker, or to light it separately. Of course, the sitter could be moved forward, but this would involve moving the camera, main light and fill-in, all of which have already been carefully positioned.

If the sitter is placed about 5 feet in front of the background it is easy to deploy a third light, and this makes a variety of effects

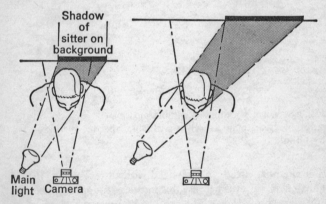

Fig. 24 Plan showing the importance of keeping the sitter far enough forward to avoid a cast shadow on the background. The nearer the light to the camera/subject axis, the greater the distance between sitter and background that will be required, unless a separate and powerful light is used to 'kill' it. But that may make the background lighter than desired.

possible. An open bulb without a reflector placed behind the subject will give a fairly even tone all over the background. Taken close to the background it will give a halo effect, with a bright centre gradually darkening towards the edges. This can be very attractive and it is quite different from a spotlight, which is more theatrical as well as much harder and therefore not so suitable for ordinary portraiture. The actual strength of tone can be varied by the use of different bulbs. If the main light is a floodlight at 5 feet, an ordinary 100 W bulb may just kill the subject's shadow on the background and leave the rest as a very dark tone. If it is not strong enough, a 150 W bulb could be employed to get a mid-key background, and changing to a photo-flood will probably give a very light tone. It is hardly necessary to add that the background light should be at the same power, either half or full, for the study of contrast and tone balance as well as for the actual exposure.

The tone of the background should always suit the subject. If the lighting is contrasty and at an angle to give plenty of texture rendering, the background should be dark and preferably have some variations of tone in a minor key. On the other hand, if the subject is more delicate and a more flattering or glamorous high-key lighting scheme is employed, the background should be light in tone with subtler variations. Nothing looks worse than a dark or contrasty head and shoulders outlined against a near white background. Likewise, a high-key subject against a black or very dark background looks bad because the moods do not harmonise.

Effect lights

The only other lights that should be considered are lights used solely to add a little sparkle to a portrait by outlining the head and shoulders. These are lights used from behind or above, and they put highlights into dark hair and help the subject to stand out from the background. They are employed a tremendous amount in films and television because they ensure that the figure will be well separated, however much he moves or how-

ever much the background changes. They are not really necessary and thousands of fine portraits are taken without them, so unless one is prepared to go to all the extra trouble and expense of boom light stands they are best forgotten. Simplicity is a virtue where most portrait lighting is concerned.

Sometimes it is found that when all the lighting has been placed to give the desired effect there is a dark patch under the chin or the eyebrows that would be better with a little more light. This can often be obtained by placing a white card or an open book on the lap so that it reflects light upwards. As an alternative, try lowering the fill-in light, but if this is done watch that it does not throw a shadow on the background above the head.

This is usually necessary only in fairly low-key work because, to be in harmony, the sitter should be wearing darkish clothing which does not reflect any of the light upwards. In high-key pictures the subject's light clothing will often do the trick, but in colour beware of colour casts. For this reason bare shoulders are often better.

Lighting by flash

Exactly the same principles of positioning and balance apply for lighting by flash, but unfortunately the precise effect cannot be seen until after a print has been made. The handyman could rig up pilot lights attached to each flash unit in order to judge the modelling, but if this is done much of the advantage of flash is lost and one might just as well use photofloods.

Experience is the best teacher, but if the advice on placing given for photofloods is followed for the flashguns there is a good chance of success. There is, however, a big difference in the nature of the light. Direct flash gives a crisp, hard-edged lighting that is good for character rendering, especially in low-key, but it is not so pleasing on a glamorous or more delicate subject. It will also require a fill-in light and a separate flash for the background, both of which need precise placing. The cost

per shot is high if bulbs are used, and for electronic flash the capital outlay is considerable.

Many people use flash bounced from an umbrella instead of direct because this often makes a second light unnecessary in a small, light-walled room at home. Owing to the lower level of light and the specular reflection scattered around the room, the background can be illuminated with an ordinary 100 W or 150 W domestic bulb behind the sitter.

When using colour it will make the background a little warmer than its true colour, but this is rarely a disadvantage. In fact, with a white background it is an advantage because pure white or grey is rarely satisfactory in a colour shot. Colour gels are useful, whether using flash or electric lighting, to put colours into a background, but always be careful to see that they do not spill onto the subject.

Umbrella flash gives such a diffused light that it is ideal for high-key or light-tone schemes even without a fill-in. These treatments are very suitable for the majority of feminine portraits as well as babies and young children, and the background should also be light. The final effect is almost indistinguishable from portraits taken in diffused daylight. For this reason it is perfect for colour, and daylight-type colour film should be used. In black-and-white the negative may well be a little too soft for printing on normal-grade paper, but this can be corrected by a little extra development if desired.

Quite contrasty results for low-key subjects can be obtained when required by using a single umbrella flash well to one side of the sitter and against a dark background. To obtain maximum contrast a large or dark-walled room should be used so that there is a minimum of specular reflection to light up the shadows.

Whether high-key, middle-tone or low-key lighting is required, the placing of the lamp does not need quite the same precision as for photoflood lighting. The cast shadows are so diffused that there is a great deal of latitude and this makes bounced flash an ideal light source for children and pets, who are

naturally restless. They can move about within reasonable limits without any necessity for moving the main light.

Points about posing

Apart from simplicity in lighting, a good portrait generally shows a simple background, unobtrusive clothing and a natural pose. Backgrounds of patterned wallpaper or folded curtains are distracting. A white or light-coloured sheet hung from the curtain rail is ideal for formal portraiture and the interest in it should be confined to tone or colour variation. A free-standing cine or slide screen can also be used for head-and-shoulder close-ups.

The clothing should be unobtrusive. Violent patterns, polka dots and loud checks can only take the viewer's attention away from the face. Dark but fairly plain suiting is best for the male character portrait, but pure black should be avoided if possible, especially for colour pictures. Pastel colours with very subdued patterns or perfectly plain materials are better for the high-key subjects. Remember always that the face is the main object of the exercise and nothing should distract attention from it. Avoid patches of light such as a pocket handkerchief in a male portrait or a sparkling brooch in the dark hair of a female.

Posing should also have an air of simplicity, and the uncomfortable look in the eyes of a sitter who has been forced to do all sorts of contortions to satisfy a photographer's desire to be different is painful to see. Always allow the subject to get seated comfortably and have a little chat or play some music until he or she relaxes. The chair should be placed at an angle so that the sitter automatically faces away from the camera. This will ensure that the shoulders are not square-on to the lens—a position that exaggerates their width and is inclined to look gauche and inelegant. With the body at an angle and the head turned towards the camera there is a feeling of movement which is pleasing, especially when the head is tilted a little.

Most sitters, particularly women, will say that 'this side is my

best side'. Often this is because there is a spot or blemish on the other, but it is not always the most photogenic. Nearly all faces are wider on one side than the other, so if the main light is directed at the wider side and the narrower side is left in shadow the final effect is of a fatter face than normal and, of course, the converse applies. If the face is already round it is rarely flattering to make it look still rounder and *vice-versa*. This is where judgment must be used.

Likewise, the desirability of suppressing less attractive features must be considered. In the case of a bald man it is better to get him to look up so that less of his pate is seen. Alternatively, the camera can be lowered to get the same effect. Double chins can be minimised by raising the camera. It is also wise to watch the nose shadow, because a large nose will look even bigger if it is allowed to cast a long shadow across the cheek.

Watch for spots of grease or perspiration, which will glisten in the lights. Keep a powder puff or handkerchief handy to make last minute corrections and ask the sitter to lick her lips to make them shine a little. Before pressing the shutter, watch for points like a jacket riding up at the back of the neck, a tie askew and wisps of hair sticking out against the background or falling over the face. Remember that retouching is practically impossible with miniature films, especially in colour.

All these points are worth watching, but the actual pose will depend on personal interpretation. 'The camera cannot lie', but the sitter can be presented in a hundred different ways to flatter, improve, eliminate or exaggerate features according to the lighting and camera viewpoint employed. A lethargic person can be made to look active by choosing a pose that has diagonals suggesting action, or another can be made to look dignified by using a low viewpoint and a tall, triangular composition.

It is a good idea to study books of good portraits and note the poses used for particular types of people. There is no better exercise than trying to copy them with appropriate subjects.

Further reading on portraiture

Camera Portraiture, Herbert Williams, Focal Press.
Light on People, Paul Petzold, Focal Press.
Lighting for Portraiture, W. Nurnberg, Focal Press.
Photoguide to Portraits, Gunter Spitzing, Focal Press.
Portrait Manual, E. S. Bomback, Fountain Press.
Portraits in Colour, E. S. Bomback, Fountain Press.

Reference book for posing
Portraits of Greatness, Yousef Karsh, Thos. Nelson & Sons.

14 Developing the Film

Black-and-white films

Anyone can develop monochrome films at home without a dark-room or elaborate equipment. It is a course much to be recommended because the individual care that can be given to the film is more reliable than the mass-machine methods employed in wholesale processing houses, especially for miniature films. In the long run it is also an economy, and there is a great deal of satisfaction to be gained from it even if the subsequent printing cannot be done at home.

The function of the developer is to turn the exposed silver salts in the emulsion into black silver and the fixing solution then removes the unexposed silver salts. Washing removes the unwanted chemicals and renders the image permanent.

The first requirement is a daylight developing tank. This can be obtained for a few pounds and the universal models will take all the standard sizes of roll film. There are also models to take one size only, and these are cheaper and use less developer. All tanks have a plastic or metal spiral into which the film is loaded and a spigot enables it to be rotated or agitated from outside. A light-tight aperture permits the developing and fixing solutions to be poured in and out.

Naturally the film has to be loaded into the tank in complete darkness. Daylight changing bags are available, but almost any cupboard or small room can be blacked out temporarily for this purpose. Loading the spiral must be done by feel, but this is surprisingly easy as long as the spiral is bone dry, and it is especially simple with several types that have a reciprocating movement.

There are also some ingenious tanks designed for 35 mm film

and 120 film that permit the entire loading to be done in daylight, but they cost about three times as much. They can be an economy if a lot of work is envisaged because only 7 oz of solution is required, against 10 to 14 oz for the other types, and they have a convenient built-in thermometer.

Much has been written about the respective qualities of different developers, but there is so little to choose between them that the wisest course is to follow the instructions given with the film. The principal manufacturers market their own developers and give precise instructions for time and temperature. Follow them and you can't go wrong. Some proprietary developers are sold in concentrated liquid form and only need diluting with water for use, after which they are thrown away. Others are in powder form, usually two separate packets, and have to be mixed with water; the solution can be used for six or seven films before being discarded.

It is advisable to filter the mixed solution before use, and in a very hard water area it might be wiser to use distilled or purified water. The makers specify the different times of development required for different temperatures between about 65°F (18°C) and 75°F (24°C), so a thermometer that reads in this range with reasonable accuracy is required. Those sold by photo dealers can be inserted in the filler aperture of the developing tank in order to keep a check on temperature during development.

The film has to be sharply agitated after the developer has been poured in so that any air bubbles on the film are dispersed. Further agitation is then required at regular intervals in order to ensure even development, but here again the instructions should be followed. Some tanks can be inverted to make doubly sure that the developer does not concentrate on any area more than another.

After development the film should be given a quick wash to remove surplus developer. Many people substitute the wash with a 'stop bath', which is a mildly acid solution that will arrest development immediately by counteracting the alkalinity of any remaining developer. This also prevents the fixing bath

from being contaminated, thus preserving its life and helping to avoid any danger of stains. Stop bath, usually called 'acid-stop', can be obtained in concentrated liquid form and used over and over again, even when diluted, so its cost per film is negligible.

After the quick wash or the stop bath the film has to be 'fixed', and this can also be bought in a convenient concentrated solution. It is best to buy the acidified type rather than the plain hypo because it is cleaner working. This can be bought in two forms, ordinary and rapid. The latter is useful for the professional in a hurry but hardly worth the extra cost for the amateur.

Up to this point the tank must be kept closed, but after the hypo has been in for a minute the lid can be removed. A few minutes after the milkiness on the film has completely disappeared, the hypo should be replaced with water or the open tank placed under a running tap. Incidentally, the hypo can be bottled and re-used repeatedly until it takes more than 10 minutes or so to remove the milkiness.

The film can be washed in two ways. Either by soaking in five or six changes of water for about 5 minutes each, or in running water for about 10 minutes. In the latter case the tank should be emptied completely at intervals because hypo tends to sink to the bottom. The temperature of the stop bath and the hypo should not be more than 10°F (5°C) lower than that of the developer, and the wash water should not be more than 10°F (5°C) less than that of the hypo. Otherwise there is a danger of the gelatine shrinking and reticulating the gelatine emulsion.

In hard-water areas the film should then be given a 2-minute soak in water to which a drop or two of softener has been added. This can also be bought in very concentrated and economical form. It will prevent scum or lime deposits forming on the film, but be careful not to overdo it or streaks may result. Here again, you should follow the makers' instructions because they have really tested it out.

The film must be hung up to dry in a place free from dust. Surplus water can be removed by gently rubbing down between finger and thumb, but wash-leathers, sponges and rubber tongs

should be eschewed. They are traps for minute particles of grit that cause 'tramlines' down the film while the gelatine is wet and soft.

If water softener is used the film should be dry in about 30 minutes. A clip or weight at the end will prevent rolling up or curling. It is best to cut the film into convenient lengths—about six exposures per length for 35 mm film or three for 6 cm × 6 cm negatives—and store them flat in plastic envelopes until ready for printing. Do not roll the whole film up for storage.

Colour negative film

Processing colour negative film is a little more complicated and certainly more lengthy than processing monochrome, but it is still within the capability of any amateur at home. The film manufacturers supply kits of chemicals that are very easy to mix and detailed instructions for their use are also supplied.

The procedure is very similar to that already described for monochrome films, but instead of a straightforward develop, stop, fix and wash there are now eight or nine operations. There is a slight variation between makes but, taking Kodacolor-X as an example, here are the steps required when using Kodak C22 chemicals:

1	Developer	14 min
2	Stop bath	4 min
3	Hardener	4 min
4	Wash	4 min
5	Bleach	6 min
6	Wash	4 min
7	Fixer	8 min
8	Wash	8 min
9	Wetting agent	1 min

This shows a total processing time before hanging up to dry of 53 minutes, as against about 30 minutes for monochrome. The first three steps must be carried out with the tank closed,

but after the hardening bath the film can be inspected by normal room lighting.

Temperature is fairly critical for the first three stages and, if the instructions are not adhered to, false colour rendering can result. In monochrome a wide variation of temperatures (about 65°F to 75°F, or 18°C to 24°C) can be tolerated if the time of development is adjusted to correspond, but with colour negative film the tolerance for the developer is only plus or minus about ½°F (¼°C) from the recommended time, which is usually 75°F (24°C).

It is therefore necessary to make some arrangement to keep the temperature constant for 14 minutes. This is easily done if the room temperature is maintained at 75°F (24°C), but failing this the tank should be placed in a tray or bath of water raised to the exact temperature.

The solutions in most kits will keep for five or six weeks without deteriorating, but they will not keep more than a few days once a film has been put through them. Since the kits will process six or seven roll films or 35 mm films, it is obviously wise to develop as many as possible at one session, otherwise the saving in cost made possible by home processing will be nullified.

Colour reversal films

Many colour reversal films are sold at a price that includes processing and they have to be returned to a processing station specified by the manufacturer.

However, there are a few that are sold exclusive of processing because they can be processed at home in the kits marketed by the manufacturers. This is a great advantage when the results are required quickly and it is also possible to use a higher speed than that for which the film is rated. It is compensated for by a longer development time. This is useful in emergencies, but there is inevitably some loss of colour quality.

The same developing tanks can be used as for monochrome or colour negative film, but there are more processing stages.

For example, Ektachrome film processed in the Kodak E-4 kit requires the following:

1	Pre-hardener	3 min
2	Neutraliser	1 min
3	Wash	1 min
4	First developer	6 min
5	Stop bath	2 min
6	Wash	4 min
7	Colour developer	15 min
8	Stop bath	2 min
9	Wash	3 min
10	Bleach	5 min
11	Fixing bath	4 min
12	Wash	6 min
13	Stabiliser	1 min
14	Dry	

The first five steps have to be carried out with the tank sealed, but the rest can be done in normal room lighting. In some processes the film has to be exposed to white light before colour development, but E-4 uses a chemical fogging procedure for reversal. Maintenance of recommended temperatures is critical to ensure good colour balance.

All this may seem rather formidable, but in practice it soon becomes routine. Like colour negative processes, the solutions do not keep well once they have been used, so it is uneconomical to process less than five or six films at a time, or at least within a few days.

The films have a milky appearance after the last wash, but this disappears as it dries and it is most satisfying to watch.

Further reading on developing

Photoguide to Home Processing, R. E. Jacobson, Focal Press.
Manual of Colour Photography, E. S. Bomback, Fountain Press.
Developing, C. I. and R. E. Jacobson, Focal Press.
Developing, Printing and Enlarging, Kodak Ltd.

15 Making Prints

We have come a long way from the days when photographers had to coat their own printing papers and then wait for a sunny day in order to expose them in contact printing frames. Today papers are very sensitive to artificial light and available in so many degrees of contrast that enlarging is feasible in any room that can be temporarily converted into a darkroom. Even colour printing is practicable for an amateur with the aid of one of the developing drums now available.

Enlarging

Miniature negatives require enlargement if the detail is to be brought out, and this demands an enlarger. There are many types available at prices ranging from £20 to £200, but they all work on the same basic principle, which is something like a camera in reverse. Light from an enclosed and light-tight lamphouse passes through the negative, and a lens placed below it projects an image onto the baseboard.

The whole unit of lamphouse, negative carrier and lens can be moved up and down the vertical supporting column in order to vary the size of the enlargement. Provision is made for focusing by means of bellows or by a helical focusing mount on the lens.

The lamphouse can be fitted with condensers or an opal diffusing glass in order to ensure even illumination all over the negative and to avoid filament images or high spots from the bulb. Condensors concentrate the light and thus require less exposure. They also add a little contrast and yield crisp images, but at the same time they tend to accentuate dust spots or scratches on the negative. Opal glass diffusers give a softer

image and tend to subdue spots and scratches but are not so efficient in passing light.

Lamphouses are often fitted with a removable tray which allows colour filters to be inserted between the light and the negative in order to obtain colour correction when making colour prints by the subtractive method. The lens must give coverage to the whole negative, so the focal length should not be

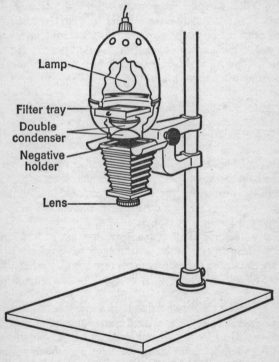

Lamp
Filter tray
Double condenser
Negative holder
Lens

Fig. 25 Cross-section of an enlarger showing the principle whereby the light is concentrated by a double condensor to provide even illumination over the whole negative.

less than the diagonal of the negative. For example, a 2 in lens is adequate for 35 mm negatives but a 3 in focal length is necessary for 6 cm × 6 cm negatives. Some camera lenses can be satisfactorily used on an enlarger, but by no means all. This is not surprising when it is realised that most camera lenses are computed to give optimum performance on subjects some distance away, whereas the enlarger demands optimum performance for an image formed only inches away. Some lenses are marked in f numbers, but most lenses made specifically for enlarging have click stops marked in a simple 2, 4, 8, 16, 32 progression, each requiring twice as much exposure as the preceding stop.

It is obvious that a good lens is the prime essential, otherwise the good definition of the camera lens will be nullified. The second important requirement is even illumination, but other facilities such as automatic focusing and built-in masking are luxuries—nice to have, but not essential.

Many people blame the softness of their prints on the lens when, in fact, it is caused by vibrations. The enlarger must be placed on a very solid bench or table and it is advisable not to walk about the room during exposure. Even a lorry passing outside can cause enough vibration to denigrate the image. Any play between the column and the baseboard or the bracket and the column will pick up external vibrations.

The negative carrier can be a simple affair that holds the negative between two metal frames or it can have two sheets of thin glass to hold the negative flat. The former, the glassless carrier, is quite satisfactory for 35 mm negatives, but for larger negatives the glass carrier is better because it prevents the negative from buckling under heat. It must obviously be kept free from dust or scratches.

All enlargers have a baseboard on which the printing paper can be placed for exposure. It is more convenient, however, to employ a printing frame, which not only holds the paper flat but also provides a white border by means of adjustable masking strips. It is painted white so that the image can be focused on it.

Focusing should be done at full aperture and then the lens should be stopped down at least one stop in order to ensure even illumination and to give enough depth of field to allow for paper thickness. There are a number of inexpensive focusing magnifiers on the market and these are useful for those who find it difficult to focus precisely, especially with dense negatives.

Enlarging papers

All black-and-white printing papers, known as bromide papers, are far less sensitive to light than films are, so they can be handled in a weak amber light. Most darkroom lamps fitted with a safe-light filter take a 15 W or 25 W bulb and the paper is safe to within about 5 feet. Nevertheless, it is a good idea to make sure by placing a coin on a piece of paper under the enlarger and on the developing bench for 2 minutes or more. Then develop it for 3 minutes, and if you can distinguish a white circle the safe-light was too strong or too close.

Bromide papers are available in a series of standard sizes from $\frac{1}{2}$ plate ($6\frac{1}{2}$ in \times $4\frac{3}{4}$ in) to 30 in \times 24 in; probably the most popular size is 10 in \times 8 in. They are also available in a large number of grades, varying from very soft to very hard. This facilitates a great deal of compensation for negatives of varying degrees of contrast. For instance, an underexposed negative or underdeveloped negative that has a very limited range of tones will require a hard or contrast paper, while an overexposed or overdeveloped negative will demand a soft paper. Most makers designate the grades by numbers. No. 0 is the softest and No. 6 the hardest, while No. 2 and No. 3 are regarded as normal and are therefore by far the most used.

Some variations in surface finish are also available, the most popular being glossy, semi-matt (or velvet matt) and matt. At one time there was a wide range of fancy surfaces such as Old Master, stipple, lustre, linen, etc., but they are falling out of fashion and even exhibition photographers use more glossy paper than anything else.

Another variation that is still available from some makers is a chlorobromide paper. It is similar to bromide but is capable of being developed to give warmer tones. It is sometimes coated onto a cream paper base, which is also going out of fashion.

For the sake of completeness, it should be mentioned that there is another type of paper known as variable contrast. Only one grade of paper is required and the degree of contrast that it records is controlled by filters placed under the enlarger lens. This sounds ideal, but there are a number of drawbacks and it has been withdrawn from the British market, although it is still available in America.

Exposure

Bromide papers are much slower than films, but exposure times with normal negatives in the conventional enlarger should rarely be longer than 60 seconds at the working aperture and, in most cases, will be considerably less. Correct exposure is essential because the print must be fully developed to get good blacks and correct tone rendition. A print that is overexposed and taken out of the developer before it has reached finality will be flat and muddy, while one that is underexposed will never achieve good blacks and maximum detail, however long it is left in the developing dish.

The right exposure can be determined in a number of ways. There are several types of electronic meters available but, like exposure meters for camera work, they have to be used with judgment. The spot-reading type depends on selecting the right tone on the baseboard to measure, and the integrating type is only reliable with an average even-tone negative. Compensation must be made for subjects having a greater than normal ratio of shadow to highlight and *vice-versa*.

The most popular method is to make a test strip by placing a small piece of bromide paper, say a quarter of the final size, in a suitable place on the baseboard or printing frame and exposing it in progressive steps, such as 5 s, 10 s, 15 s, 20 s, 25 s, 30 s, by drawing a piece of opaque card across in stages.

Alternatively, you can use one of the commercially available step wedges or enlarging test negatives. These enable you to get the same result with one exposure.

After full development the test print can be examined in the fixing bath and it will be easy to see which exposure was correct. An advantage of this method is that it also gives an indication of whether or not the correct contrast grade has been chosen.

Some enlargers are fitted with an orange or red filter that can be swung into place under the lens. It is a mistake to use this for making the exposure because it is all too easy to vibrate the enlarger head and soften the print when swinging it in and out of position. The exposure should always be made by a switch that is remote from the enlarger itself—a footswitch is ideal. There are also automatic timers available. These ensure consistency and thus are useful if repeat prints are required. More elaborate models combine timer and exposure meter and, at the same time, switch the darkroom light on and off.

A great advantage of enlarging is that parts of the picture can be 'shaded'. This means that parts can be printed up or held back. For instance, if the sky in a landscape negative is very dense compared with the foreground, it can be given extra exposure by holding a suitably shaped mask cut from opaque card over the landscape portion. The card has to be held a little above the paper and kept on the move to avoid a sharp edge appearing. In portraits it is sometimes an advantage to shade a light background so that it darkens towards the edges. The keen printer keeps an assortment of different shaped masks beside him for such purposes.

However, it is obvious that such manoeuvres would be difficult to execute accurately in a space of just a few seconds and this is where the f stops or click stops on the lens can be very useful. By stopping down, the exposure time can be increased to 30 seconds or more and this is the only valid reason for using small stops on most enlarger lenses, which are generally designed to give optimum results at the larger apertures.

Contact prints in the enlarger

Many photographers like to make contact prints for filing or record purposes and this is easily done with an enlarger. If a 35 mm film is cut into strips of six negatives, it will be found that the five strips just fit neatly into a 10 in × 8 in area when placed side by side. Likewise, a 120 size film cut into four strips of three negatives each just covers 10 in × 8 in. Therefore all that is necessary is to place a piece of grade 2 or grade 3 bromide paper face up on the baseboard, lay the negatives on top emulsion downwards, and keep them flat and in place with a sheet of heavy plate glass 10 in × 8 in or larger.

Then make an exposure with the lens closed down one or two stops and develop the print. Once the correct exposure has been found it can be repeated ever afterwards if the enlarger head is always at the same height. This presumes that all the negatives are fairly constant in density, failing which a little masking during exposure may be necessary, but for filing and identification purposes optimum quality in all the pictures is not vital. If a lot of contact work is anticipated it is a convenience to use one of the inexpensive frames designed for the purpose.

Processing monochrome prints

Three dishes are required for print processing and they should be at least an inch or two bigger all round than the prints to be processed. The first dish, the developer, should also be deep enough to be able to rock it without spilling, and a minimum of 2 inches is desirable.

Print developers of a simple metol-hydroquinone formula are available as concentrates which only have to be diluted with water. Ideally, they should be kept at a temperature of about 65°F (18°C) and, since this is a comfortable room temperature, it should not be difficult. The exposed paper is slid smoothly into the developer, emulsion side up, and the dish gently rocked for a few seconds to remove air bubbles and ensure even spreading if the developer is newly mixed. It is a great temptation to

watch the image come up, but this is not really necessary because the print should stay in for at least 2 minutes. Under darkroom lighting the print always looks as though it is getting too dense and there is a temptation to remove it too soon as a result.

When examined in white light after fixing, a print will be seen to be much lighter than it looked under the darkroom safelight. Therefore the test strip for determining exposure should always be examined by ordinary electric lighting or, if possible, by daylight.

After full development the print is transferred for a few seconds to an acid stop bath similar to that used in negative development. After this it is transferred to the fixing bath and the room light can be turned on. In order to avoid contamination between baths, a pair of plastic print tongs should be used to to lift the print from developer to stop bath and another pair to lift it from the stop bath to fixer. This keeps the hands dry and also enables the print to be drained of surplus liquid between each bath.

The fixing bath can be plain hypo, but acid-hypo is cleaner working and less liable to staining if the print is left in it too long. This can be bought in powder form and only needs dissolving in water. Five minutes is usually adequate for fixing if the prints are kept on the move and not allowed to cling together. A longer time, up to an hour or so, will do no harm, but longer than this may cause some bleaching.

All prints require a thorough washing or they will start fading in time. If running water is available 30 minutes is sufficient, but the prints should be kept on the move. A simple siphon can be used to adapt a bath or washbasin for the purpose and, ideally, it should drain off the water from the bottom because the salts washed out of the prints tend to sink.

Where running water is not available the prints should be soaked for 5 minutes at a time in seven or eight changes of water, and if absolute permanence is required it would be as well to employ one of the commercially available hypo eliminators.

Drying

Prints can be dried naturally by laying them face upwards on newspapers and removing the surplus water with fluffless white blotting paper to avoid the risk of uneven drying marks. Prints should not be hung up to dry because they stretch or curl up.

The most convenient and the quickest method of drying is to use an electric print dryer, either of the economical flat-bed type or the more expensive rotary-drum type. With these, prints made on glossy paper can be glazed and given an almost glass-like finish, especially if they are soaked for a short time in a proprietary glazing solution.

Processing colour prints

Until recently colour printing was beyond the scope of most amateurs, but improved apparatus and materials have now made it comparatively easy. The colour negative is projected through the enlarger lens just like a black-and-white negative, but the light has to be corrected with colour filters.

There are two methods: additive and subtractive. The former needs three filters in the primary colours—red, green and blue— and they can be used below the lens. It is fast becoming obsolete. In the subtractive method a set of thirteen or more colour filters are required. These are cyan, magenta and yellow in various degrees of density, and since several may have to be used together it is better to place them in the filter drawer provided in the lamphouse of many enlargers. They should be scrupulously clean, but gelatine filters are quite satisfactory if they are not scratched or fingermarked.

In black-and-white printing the density is controlled by the exposure, but in colour printing both density and colour are affected, so the colour of the light nearly always has to be modified by filters. This also means that there must be some form of voltage control applied to the lamp because variations in voltage can change the colour temperature of the light.

The subtractive method of colour printing is the more satis-

factory and offers wider control over the final result. It would be out of place to go into detail about the selection and use of filters—there are many books on the subject—but suffice it to say that a test print has to be made without filters or with a pre-selected combination. From this, adjustments can be made if there are any colour variations or colour cast.

At one time this was very difficult and sometimes many test prints had to be made; even worse, they had to be dried before the final colour could be assessed. Today, with the aid of graded test charts containing a number of sections of different colour densities, the corrections can be made from the examination of one test print. The exposure adjustment necessitated by altering the filter combination is also given.

All makes of colour printing paper are naturally sensitive to light of every colour, so the handling must be carried out in complete darkness or by the very dim light of the safelight recommended by the paper manufacturer. However, the actual processing is no longer a problem because there are developing drums available which are efficient and economical.

The print is loaded into the drum in darkness after it has been exposed in the enlarger and from then on the processing is done in white light. The solutions are poured in and out through a light-tight aperture and the drum is rotated or rolled backwards and forwards to provide even working with only a few ounces of solution. In the more elaborate professional models the drum is sometimes turned by an electric motor and it is contained in a temperature-controlled water bath. Temperature is critical to within about $\frac{1}{2}°F$ ($0.25°C$) for the developer and about $3°F$ to $4°F$ ($1.5°C$ to $2°C$) for the other baths.

Temperature control is not difficult if the room is kept at the right temperature, and the bottles containing the solutions are kept in a water bath at the precise temperature required. This avoids any increase or decrease due to pouring into a cold container or drum.

Processing times vary a little between makes, but the instructions given with Agfacolor paper are fairly typical:

1	Developer	5 min
2	Wash	2½ min
3	Stop-fix	5 min
4	Bleach-fix	5 min
5	Wash	10 min
6	Stabiliser-hardener	2½ min
		30 min

No further washing is required, and the print can be dried by placing it on a newspaper and squeezing the surplus water away. It should not be put through a glazing machine.

Colour prints from transparencies
Prints from transparencies can be made in the enlarger by the subtractive method, using reversal papers for the purpose. This naturally entails a reversal of filtration and the processing in most cases calls for five baths and a reversal exposure to white light. There are fourteen steps and the total time is about 24 minutes.

However a recently introduced process called Cibachrome-A has made it much easier. There are only 3 steps and no reversal exposure is required. Total time is about 12 minutes per print when using a developing drum and the results are remarkably good, being very sharp and with a high degree of colour saturation. Unlike other methods Cibachrome-A has a wide latitude in exposing and processing and the prints are more resistant to fading.

Monochrome prints from colour negatives
Most makes of colour negative films have a built-in orange mask which makes them difficult to assess without a lot of experience, so it can be useful to make black-and-white contact prints or enlargements before spending time on colour prints. Ordinary bromide papers can be used, but the required exposure will be very long owing to the colour of the mask and there will be some distortion of image tones.

Special papers such as Kodak Panalure are made for the purpose and they will translate the colours into appropriate tones more accurately. As they are colour sensitive they must be exposed and developed in complete darkness or by a very, very dim safelight.

For the man with a penchant for darkroom work there is nothing more satisfying than colour printing, but makers' instructions have to be observed closely. Improvements making colour printing easier and more economical are being introduced frequently, so the keen printer should keep himself constantly up to date through the usual sources of books and magazines.

Recommended reading

Developing, Printing and Enlarging, Kodak Ltd.
Photoguide to Enlarging, Gunter Spitzing, Focal Press.
Making and Printing Colour Negatives, John Vickers, Model & Allied Publications.

16 Presentation

The impact on viewers of both prints and transparencies is greatly enhanced if they are presented properly. Even the best pictures lose a great deal if they are allowed to become dog-eared in the pocket or if transparencies are projected with specks of dust all over them.

Mounting prints

Prints, whether in colour or black-and-white, should always be mounted, even for carrying in the pocket book or handbag. Prints for preservation in an album should not only be properly mounted but also displayed in an artistic way that will add variety and interest. Page after page of photographs that are all similar in size and positioning makes an album monotonous, however good the pictures may be.

Photographs for the pocket can be mounted on card and preserved from dust and scuffing by being placed in a transparent envelope. It is also possible to have them heat-sealed in clear plastic, and experience so far would indicate that the sealing does no damage to the print.

Albums at one time had slots pierced in the pages so that prints could be dropped in or attached by the corners. They have become obsolete because one is tied to the same size of print throughout and it is impossible to trim prints or provide any variety in presentation. Adhesive corner pieces were also popular at one time and they at least gave scope for versatility in size and layout, but unfortunately they rarely stayed stuck for more than a year or two.

There are three types of modern album that overcome all these drawbacks. The first consists of leaves, or more precisely envelopes, of fairly thick clear plastic. A sheet of thin card

of any desired colour can be inserted and prints mounted on either side. This enables the user to get variety by having leaves of different tints as well as black or white, and to change the pictures and the order as and when required.

The second type consists of an album with plain pages of white, grey or cream card and is often of the loose-leaf variety. One is tied to the colours provided, but there is plenty of scope for making interesting layouts and for lettering titles or captions. The loose-leaf type is usually better because it is easier to mount prints when the page is removed and it also folds out flat when being viewed.

The third type of album is one that is becoming increasingly popular. It consists of pages of fairly stout card, usually white or off-white, covered with a very thin plastic. The plastic is peeled back and prints are placed in the desired position, after which the plastic is rolled or smoothed back over the prints. It adheres to the mount between the prints because it is treated with a mild adhesive but, with care, prints can be removed if desired. The effect is very clean and modern and has the great advantage that no separate print mounting is required, but there is a disadvantage in that the mounts will not take lettering owing to the adhesive surface. This means that captions or titles must be separately typed or written on paper and mounted in place like the prints. Most of these albums are also loose-leaf.

Prints can be mounted with ordinary adhesives, but there are risks unless photo-mountants especially developed for the purpose are employed. Ordinary gums and glues sometimes have a chemical reaction with the paper or the mount which, in time, will cause staining or deterioration. In the case of water-based glues there is also a danger of uneven shrinkage or cockling, especially with large prints.

A recent introduction is a photo adhesive in an aerosol spray can. This is a quick, easy and clean method in which the back of the print is sprayed and then pressed into position. It works very well and is chemically quite safe, but it is comparatively expensive.

By far the most satisfactory method of mounting prints of any size is that known as dry-mounting. A sheet of very thin shellac tissue, obtainable at photo-dealer shops, is attached to the back of the print by one or two touches with a hot iron, which can be a domestic smoothing iron or a soldering iron. The print and tissue are then trimmed together so that they are both exactly the same size. They are then laid on the mount and a hot iron is applied over the print. This melts the tissue and a perfect bond is secured.

There are special dry-mounting presses available for professional use, but an ordinary smoothing iron will make a good seal in 30 to 60 seconds. A sheet of good-quality greaseproof paper should be placed over the print to protect it from scorching; alternatively, metallic cooking foil can be used. The tissue forms an impervious layer between print and mount, thus preventing any impurities in the mount from scratching the emulsion. The shellac can be purchased in liquid form as well as tissue, but it involves an extra operation because it has to be spread on and left to dry. The saving in cost is hardly worth it.

Another advantage of dry-mounting is that it can be used on any dry and smooth surface, so prints can be mounted on wood blocks, chipboard or hardboard. The last-named is very useful for photographs that are to be framed.

Framing is very much a matter of personal taste and, in any case, should suit the surroundings in which the picture will be hung. In deciding where it is to be hung it is important to remember that colour prints are inclined to fade when exposed to sunlight for any length of time. It is possible to use an anti-fade varnish which preserves them a little longer, but it is better to hang them in the shady side of the room whenever possible.

At one time it was fashionable to mount photographs on white or cream mounting board and leave a margin of several inches all round the print; this included prints for exhibition or for framing at home. The side margins were each about one fifth of the width of the print, while the upper margin was slightly less and the lower margin slightly more. Today flush-mounted

prints are the vogue and these are often on glossy paper, presumably as a result of glass going out of fashion.

For domestic showing, especially in a modern décor, prints can be mounted in very thick clear plastic—even as thick as 1 in —and this gives them an attractive and unusual 'floating' appearance. Mounted in this way they are also suitable for standing on the table. A popular type of mount for exhibition as well as for home decoration is one where the print, which is flush-mounted on hardboard, is then flush-framed at the back with wood about 1 in × 1 in. This gives the appearance of a solid block and the edges can be painted in a suitable colour or covered with a metallic tape. The effect is elegant and modern, and the picture can be easily hung flush to the wall.

For the period home, however, a normal picture frame is probably better. Curiously enough, a frame almost demands a mount around the print—something that is by no means necessary for a painting. It can be in any colour that harmonises with the print as well as the general décor, and coloured canvas is often used. For a high-key print a black or very dark mount is popular because it emphasises the luminosity of the picture, but for contrasty and deep-hued colour photographs a pastel shade is usually preferable. Try holding the print against different coloured papers or handy walls and it will be seen immediately that the colour of the mount can make a vast difference to its appearance. As with most things, simplicity, if not a virtue, is at least a safe course and in good taste.

Projecting slides

The beauty of a colour slide cannot be appreciated to the full until it is projected, but all too often the presentation is so bad that viewers get bored even when the slides are full of subject interest. Holding a slide up to the light reveals none of its detail and the colours look too cold. Battery-powered hand-viewers that magnify the picture are useful for preliminary examination or for sorting purposes and the light provided by a

torch bulb gives a reasonably good colour rendering. However, one cannot conveniently share the pleasure of viewing with others by this method, so projection is the answer.

With a good projector and screen the slides are seen in a greater brilliance and range of tones than any colour print can reflect. The colours are purer and more intense, and there is often a marvellous impression of depth.

There is an enormous variety of projectors available to take 2 in × 2 in mounted slides, and they cover a wide price range

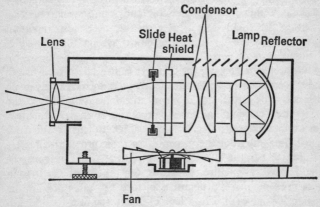

Fig. 26 Cross-section of a typical 2 in × 2 in slide projector.

according to construction and specification. This size takes 35 mm or 126 size transparencies as well as half-frame because these are all normally mounted in 2 in × 2 in card mounts when returned from the processer. Adaptors are also available to project the miniature 110 size but, of course, the picture on the screen is correspondingly smaller. If this size is used exclusively it is better to get one of the projectors especially designed for them.

There are also a few projectors made to take 6 cm × 6 cm (2¾ in × 2¾ in) transparencies made on 120 film. There is at

least one model made to take both 2 in × 2 in and 2¾ in × 2¾ in, but since two lenses or a zoom lens are required and the optical system is necessarily rather sophisticated it is in a high price bracket.

The cheapest 2 in × 2 in projectors have a comparatively low-power lamp, about 100 W or 150 W, so no cooling system is required. They will give quite a good picture up to 3 ft or 4 ft wide in a darkened room. Higher priced models have more powerful illumination, which facilitates greater magnification and some have refinements such as remote control, automatic focusing, automatic slide changing and sound synchronisation facilities. When choosing a projector the three most important considerations are the lens, the optical system and the slide-changing system.

The projector lens, like the lens on a camera, has a focal length and this controls the size of the picture on the screen at any given distance. The larger the room, or the longer the throw, the longer the focal length must be to produce a given size of picture. For example, the popular 85 mm focal length lens at a distance of 8 ft (2·2 m) from the screen gives a picture approximately 3 ft 5 in × 2 ft 3 in (1 m × 0·75 m), but at 10 ft the same lens would give a picture approximately 4 ft 2 in × 2 ft 10 in (1·25 m × 0·9 m). To obtain a picture the same size as the 85 mm lens gives at 8 ft, a lens of about 100 mm focal length will be required at 10 ft.

Most lenses have an aperture of about f/2·8 but, for obvious reasons, no iris diaphragm is fitted. There are also zoom lenses available in the higher price ranges, and these can be very convenient if the projector is used in different places that demand variations in picture size.

The table opposite shows the approximate size of image given by 35 mm transparencies with lenses of the popular focal lengths. For half-frame pictures divide the longer dimension by two, and for 110 pictures divide both dimensions by two. A separate table is given for 126 transparencies.

These sizes are rounded off to the nearest inch, but small

Image sizes for 35 mm transparencies in 2 in × 2 in projectors

Focal length	Distance from lens to screen						
	8 ft	10 ft	13 ft	16 ft	20 ft	23 ft	26 ft
50 mm	5'8" × 3'8"	7'3" × 5'	9'6" × 6'3"	12' × 8'	14'4" × 9'6"	16'8" × 11'2"	19' × 12'8"
85 mm	3'5" × 2'3"	4'2" × 2'10"	5'8" × 3'8"	7'1" × 4'8"	8'4" × 5'8"	9'8" × 6'6"	11'4" × 7'6"
100 mm	2'8" × 1'9"	3'8" × 2'6"	4'9" × 3'2"	6' × 4'	7'2" × 4'9"	8'4" × 5'7"	9'6" × 6'4"
120 mm	—	3' × 2'	4' × 2'8"	5' × 3'4"	6' × 4'	7' × 4'8"	8' × 5'4"
135 mm	—	2'10" × 1'10"	3'6" × 2'4"	4'6" × 3'8"	5'8" × 3'8"	6' × 4'	7'1" × 4'8"
150 mm	—	2'4" × 1'6"	3'2" × 2'1"	4' × 2'8"	4'8" × 3'2"	5'8" × 3'8"	6'4" × 4'2"

Image sizes for 126 transparencies in 2 in × 2 in projectors

Focal length	Distance from lens to screen				
	6 ft	8 ft	10 ft	12 ft	14 ft
50 mm	3'3" × 3'3"	4'5" × 4'5"	5'2" × 5'2"	6'7" × 6'7"	7'1" × 7'1"
85 mm	2'2" × 2'2"	2'7" × 2'7"	3'4" × 3'4"	4'1" × 4'1"	4'7" × 4'7"
100 mm	1'6" × 1'6"	2' × 2'	2'6" × 2'6"	3'1" × 3'1"	3'7" × 3'7"
120 mm	1'3" × 1'3"	1'9" × 1'9"	2'2" × 2'2"	2'7" × 2'7"	3'1" × 3'1"
135 mm	1'1" × 1'1"	1'7" × 1'7"	1'10" × 1'10"	2'4" × 2'4"	9'9" × 9'9"

variations may occur because lenses, especially the cheaper ones, are not always precisely the focal lengths marked on their mounts.

It is important to have as long a throw as the room will permit, after allowing enough room for operating the projector from behind. A short throw means that viewers will be uncomfortably close to the screen or at such an angle that the picture will appear badly distorted.

Having decided the distance available, reference to the table will show the size of picture available for each focal length. The picture must not be too big in relation to the distance or the audience will feel 'swamped' and unable to absorb the whole picture in one glance. It can also strain their necks. At 10 ft throw, a picture 4 ft wide is ample and it will still look good at 13 ft. In larger rooms and with larger audiences, correspondingly bigger pictures can be acceptable, but for home use a 4 ft picture is adequate. A popular screen with amateurs is 50 in × 50 in, but screens are also available at 3 ft, 5 ft and 6 ft square.

The optical system on a good projector consists of a bulb, sometimes with a reflector behind it and sometimes with the reflector built into the bulb, a condensor, a heat-resisting screen and the lens. Nearly all quality projectors now use low-voltage tungsten halogen lamps, which are cooler and more compact than the old gas-filled bulbs and burn with a white light that gives better colour rendering. They do not change temperature with age and they are optically more efficient because the filaments are smaller. The popular sizes are 12 V/100 W, 24 V/150 W and 24 V/250 W.

The slide is inserted between the lens and the heat filter, or where no filter is fitted between lens and condensor. The simplest form of shift carrier is of the push–pull type. It has two apertures so that, while one slide is being projected, another is being inserted in the other slot or aperture and then pushed into place when required. The previous slide comes out on the other side for removal.

This is a somewhat tedious business when there are many slides to show, so the majority of modern projectors have a carrier that holds thirty-six or fifty slides and these are pre-loaded. The carrier then moves forward automatically as each slide is shown. Another version is in a circular form and may take about eighty slides in one loading. This type permits continuous projection, which is useful for some commercial purposes. Provision is made on more advanced projectors for removing any one slide for separate examination and this overcomes an early objection to carrier projectors. Some people even use the carriers as a filing system, which saves the trouble of loading up before a show, but it is rather an expensive method of filing.

On most projectors there is provision for reversing the carriage in order to go back to a slide previously shown, and on many there is a remote control that enables the operator to control the advance or reverse from a distance. Many also have provision in the remote control for focusing by means of a button operating a small electric motor built into the projector. There are some models that have completely automatic focusing by means of a light beam which is beamed onto the transparency and reflected back to a two-part photocell. When the beam does not fall equally on each part, the motor adjusts the lens until it does.

All but the smallest and cheapest projectors have electrically driven fans that direct a current of air upwards through the slide chamber, and these are generally very quiet in operation. It is most important to ensure that the projector is clear of any obstruction so that there is a free ingress of air. Propping it up on books instead of standing it flat on its own legs may well block up the entrance with disastrous results.

Another feature found in good projectors is a masking device so that the screen is blacked out during a slide change. Without this the audience is subjected to a brightly lit screen between each slide, and this makes the slides appear less brilliant. It is also rather tiring.

Sound slide projection

The addition of sound to a slide show is becoming increasingly popular, largely due to the efficiency of modern tape-recorders, and the tape can be made to effect the slide changes. In one method the tape runs over a synchroniser attached to the tape-recorder and short strips of metal are spliced into the tape at the points where a change is required. When the metal passes over contacts connected to the remote control of the projector, the circuit is closed and the slide changes.

There is also a more sophisticated method in which the slide change signals are recorded electrically on the tape. If it is recorded on the second track of a twin-track recorder, it will be inaudible and the position of the signals can be changed at any time if required.

In recent years a number of enthusiasts have started employing two projectors so that a picture from one projector can be lapped, faded or dissolved in over the slide in the other projector as that one is faded out. The sequence can also be controlled by pulses, this time on a four-track tape, and the presentation is thus very polished and professional. However, some of its exponents prefer to do the changes by hand so that the speed of the overlaps can be varied. At least one system uses iris diaphragms in front of the lenses in order to obtain slow or fast fades and dissolves at will.

Projection screens

A good screen is essential if slides are to be seen at their best. A wall is no substitute as it is too absorbent and is, in any case, not always white or in a convenient place. Screens can be obtained for hanging from the picture rail or for permanent erection, but by far the most convenient for home use is the portable type which rolls up and has a folding stand. There is also a self-erecting type which rolls out of a box that can be stood on a table or other convenient support. Most folding or self-erecting screens have two positions: one gives the correct

format for cine projection and the other is square in order to take 35 mm slides horizontally or upright.

There are three types of surface in general use: matt-white, lenticular and glass-beaded. Matt-white screens are the cheapest and are made of fairly opaque cloth. They can be viewed from a wide angle without a noticeable loss of brilliance, so they are useful in large rooms or where people have to sit at an angle to them.

Lenticular screens have minute vertical and horizontal ridges and hollows which act like a myriad of tiny lenses that have great reflective properties, so a brilliant image results. They are usually painted silver and also have a good viewing angle but, of course, they are much more expensive than matt-white screens.

Glass-beaded screens have myriads of tiny crystal glass beads impregnated in the canvas surface. They are by far the most efficient in terms of brilliance, but they are very directional and the full benefit is only seen by those sitting at no greater angle than about 20° from the centre. At a greater angle the apparent brilliance falls off rapidly, but it is still better than a matt-white screen, even at 35°. Beaded screens are therefore ideal for long, narrow rooms but not so good for domestic use if a number of people are to be seated in an average sitting-room. They have to be stored when not in use because the surface tends to turn yellow if exposed to daylight for long periods.

A cheaper version uses plastic beads instead of glass. It is naturally not so efficient but is considerably better than matt-white. At one time screens treated with silver or aluminium paint were popular, but they are not good for colour and so are now almost obsolete, except in the case of lenticular screens where colour is not affected because of the surface construction.

Mounting slides

35 mm transparencies are returned from the processors mounted ready for projection unless otherwise ordered. Kodak returns Kodachrome transparencies in 2 in × 2 in cardboard mounts that are numbered consecutively from 1 to 36 in the order in

which they were taken. The other principal manufacturers, Agfa, Perutz and Fuji, return theirs in plastic mounts, which are neater and more rigid but are not numbered. In all cases the transparency itself is exposed and therefore vulnerable to dust, damp, fingermarks and scratches.

Although transparencies can be projected in this form, they are liable to 'pop' in the projector and this can be very irritating because it demands constant refocusing. All transparencies that are of any value and are going to be retained for long periods should be mounted in glass, especially if they are going to be projected or handled frequently.

There are many ingenious proprietary brands of mounts available, most of which are in the form of two thin plastic frames with very thin glasses. The transparency is placed in position, sometimes hooked on pegs that fit the perforations, and the two halves are clipped together. This type of mount is expensive but, on the other hand, it is re-usable and the transparency can be changed as often as required. The big disadvantages of proprietary mounts are that they are neither dustproof nor air-tight.

The most satisfactory, and the cheapest, mount is the one you make yourself. All the materials can be obtained at any photodealer's shop. Thin cover glasses cut exactly to size are obtainable in packets of 50 or 100 and masks cut from thin paper or metal foil hold the transparency in the right position. The sandwich of glass, transparency and glass is then bound with a thin binding tape sold especially for the purpose. You can even buy the tape already cut and with corners mitred. An inexpensive jig makes binding easy and accurate.

One type of cover glass has a finely etched surface which reduces the risk of Newton's rings. These are concentric bands of coloured light that sometimes form between the back of the film and the glass when they are not in perfect contact. This, of course, shows up on the screen.

Properly mounted in this way the transparency will remain dust-free for life and, provided that it was perfectly dry before

mounting, it will also be protected from the fungus that can form on slides stored in humid conditions.

The masks already mentioned can be purchased with apertures to take 35 mm, 126, half-frame or 110 transparencies and also with special shapes like ovals, rhomboids, circles, etc. The latter should be avoided because they interrupt the smooth flow of a slide presentation. However, some masking is often justified to improve the composition of a picture. Landscapes are sometimes improved by masking to a narrow horizontal format and many architectural pictures are better for removing some of the foreground. Likewise, tree pictures, and even portraits, are occasionally improved by masking them to a tall and narrow format. It is essential, however, that the centre line of the picture corresponds to the centre line of the slide. Nothing is worse than a picture that appears off-centre, or to one side of the screen, only to be followed by one that 'leaps' to the other side. A narrow landscape can be slightly above the horizontal centre line, but its edges must reach the edge of the screen at each side or be an equal distance from each side.

Before mounting, the transparency should be kept for a while in a warm (not hot) place, say above a radiator, for an hour or two to remove any residual damp. It and the cover glasses should be gently cleaned with an anti-static cloth or brush. Do not breathe on them or try to blow dust away—it will merely put moisture back into the emulsion. Never use any binding tape except that sold especially for the purpose. Under the influence of projector heat other tapes may dry up and come off or, worse still, ooze gum.

Every slide should be marked so that the projectionist knows which way to insert it in the gate or carrier. It is disturbing to the flow of a slide show when a picture appears upside down, on its side or reversed left to right. There are actually eight ways in which a slide can be inserted and only one is right.

The universally accepted system is to put a small white spot about a $\frac{1}{4}$ in diameter in the bottom left-hand corner when looking at the transparency the right way up and the right way round.

The projectionist, standing behind the projector, inserts the slide with this spot appearing at the top right corner, i.e. under his thumb, and the picture then appears the right way up on the screen.

Fig. 27 The way to spot a slide. With the picture the right way up and the right way round, the spot is placed in the bottom left-hand corner. The spot should come under the operators thumb when inserting the slide in the carrier or projector, i.e. with the picture upside down but the right way left to right.

Gummed spots can be bought in different colours and with consecutive numbers printed on them. They are inclined to come off if stuck on the glass, so it is better to stick them on the paper mask before the slide is mounted. It is also a good idea to put titles, name and address or any other required data on the mask rather than on the outside of the slide. Strips and spots that become detached can foul up the projector mechanism, and if slides are entered for competitions they may get lost or disqualified.

Some of the available ready-cut binding strips are black with a white strip or line arranged to appear on one side of one edge. This is an alternative to spotting, and the tape should be

arranged so that the white strip appears along the bottom edge when the transparency is the right way up and the right way round. It is inserted in the projector with the white line at the top and facing away from the screen.

The total thickness of the slide should not be more than 0·125 in, but this is no problem if the materials sold for the purpose are used. It is not normally possible to bind card-mounted transparencies like Kodachromes between two cover glasses without removing the card because the 'sandwich' will be too thick for most projectors. It also leaves an undesirable air space on each side of the film.

The plastic mounts in which some makes of transparency are returned are white on one side and coloured on the other. The white side should face the rear when inserting them in the projector, but it will still be necessary to spot each slide to avoid putting it in the right way up, which will cause it to appear upside down on the screen.

Storage of slides is important. There are many boxes and magazines available that keep the slides separated from each other, and the only essential requirement is that they are kept in a dry place. Damp and humidity is the enemy of all photographic emulsions because it encourages mould and bacteria to form in the gelatine. Slides should not be left exposed to daylight, especially sunlight, for long periods as there is a tendency for the fugitive dyes to fade.

When a show is made up it is convenient to store the slides in the correct order and the right way up in a suitable magazine or box. If a line is painted diagonally across the top edges it will be very easy to reassemble them in the correct order should they become separated or mixed up. A dab of nail varnish on each slide is good for this purpose.

Making up a show

When selecting slides to make up a show, even just for friends at home, and whether they are of holiday, travel or specialist interest, it is necessary to be absolutely ruthless and reject any

Fig. 28 A good dodge when filing slides is to paint a line across the top at a diagonal. It will then be easy to rearrange them in the right order if they get mixed up.

slides that are under- or overexposed, however important the subject matter may seem to be. Jumping from dense to thin slides is very irritating for the audience. The subject matter should be arranged in a logical or chronological sequence and there should never be more than one slide of a particular scene, however good the other shots taken at the same time may be.

As a general rule, a presentation should not exceed 100 slides, otherwise the audience will get fidgety or picture-drunk. Except for slides that require special comment or contain some important reading matter, no picture should remain on the screen for more than 20 seconds at the maximum. It is a good idea to introduce some variation by giving a picture full of detail more screen time than a close-up portrait, while a slide of a simple subject like a single flower could have even less.

Title slides give a professional touch. These can be made by lettering in black or in colour on plain white card, and adhesive letters like Letraset make this easy. The artwork is then photographed and the resulting transparency can be bound in with another. For example, 'Our holiday in Greece' bound in contact

with a picture of the Acropolis will set the right atmosphere from the start. Something similar can be made for the 'End' or 'Finis' slide, as well as for intermediate title slides when there is a change of subject.

A tape-recorder or record-player can be used to create an impressive atmosphere by playing appropriate music or sound-effects. Music that is typical of the country being depicted in a holiday show can be augmented at the start with the sound of an aircraft taking off. Bird pictures can be accompanied by bird calls, cars with horns blowing, etc.—the possibilities are endless. There are no problems with copyright if the music is not played in public. Most gramophone dealers now sell records of common sounds, animal noises, bird calls, trains approaching and receding, sirens wailing, thunder claps, etc., and it is easy to transfer the required parts to a continuous tape.

It is a courtesy to an audience to prepare a show in advance with the projector in position and ready focused. The carrier should be loaded into the projector with the first slide in place so that nothing is needed but to switch on. Never be diffident about showing slides and don't reluctantly drag them out when the room is already full of smoke. Have some background music playing when guests arrive, see that the room is properly blacked out, and get on with it in a meaningful and professional manner. The slides will be appreciated all the more.

Further reading

Projecting Slides, M. K. Kidd and C. W. Long, Fountain Press.
How to Title, L. F. Minter, Focal Press.

Bibliography

Photographic periodicals

Weekly

Amateur Photographer. The world's largest photo magazine. Caters for all amateur interests in still and cine photography. Published by IPC Business Press, Surrey House, 1 Throwley Way, Sutton, Surrey SM1 4QQ.

Monthly

Creative Camera. Aimed specifically at the avant-garde and 'way-out' type of photographer. Coo Press, 19 Doughty Street, London WC1.

Photography. General interest magazine with emphasis on travel. Argus Press Limited, 14 St. James Road, Watford, Herts.

Photo-Technique. General interest magazine mainly appealing to the technically minded amateur. Penblade Publishers, 50/60 Wigmore Street, London WH1 OBY

Practical Photography. General interest but emphasis on do-it-yourself and practical aspects. East Midlands Allied Press Ltd., Park House, Oundle Road, Woodston, Peterborough.

S.L.R. Camera. General interest for amateurs but dealing almost exclusively with single-lens-reflex cameras. Haymarket Publishing Ltd., Craven House, 34 Fouberts Place, London W1

Annual

B.J. Annual. Contains a large selection of the year's best pictures plus technical features and a section giving basic formulae. H. Greenwood & Co., 24 Wellington Street, London EC2E 7DH.

Photography Annual. Devoted entirely to reproductions of good pictures in black and white and colour with some emphasis on photo-journalism. Argus Press Limited, 14 St. James Road, Watford, Herts.

Elementary books of general interest

The Complete Photobook, Ronald Spillman, Argus Press Limited, 14 St. James Road, Watford, Herts.
The All-in-One Camera Book, Walter Emmanuel, Argus Press Limited, 14 St. James Road, Watford, Herts.

Index

TEACH YOURSELF BOOKS